the
ACRYLIC
PAINTER

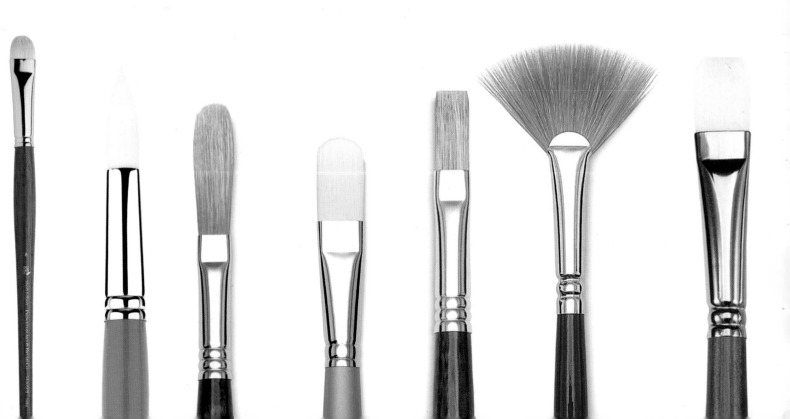

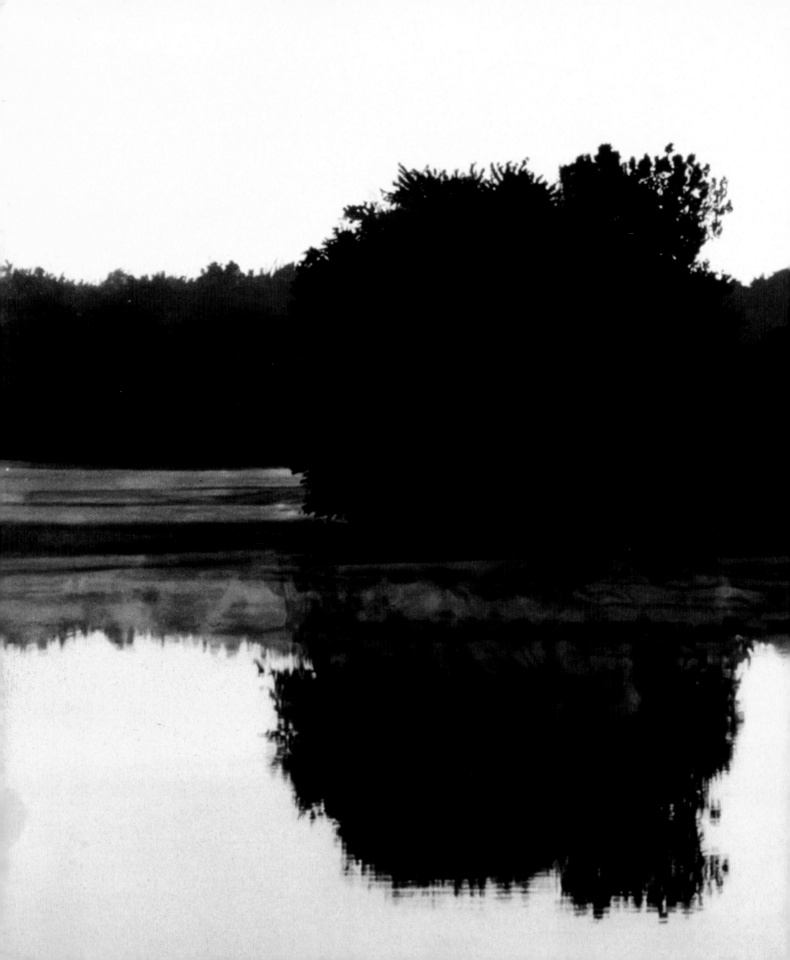

the
ACRYLIC
PAINTER

Tools and techniques for
the most versatile medium

JAMES VAN PATTEN

WATSON-GUPTILL PUBLICATIONS
BERKELEY

Notice what you are noticing.

–Allen Ginsberg

To Gillian, my muse,
who has made both my art and my life possible,
bringing color and light to what I see,
and love to my soul.

CONTENTS

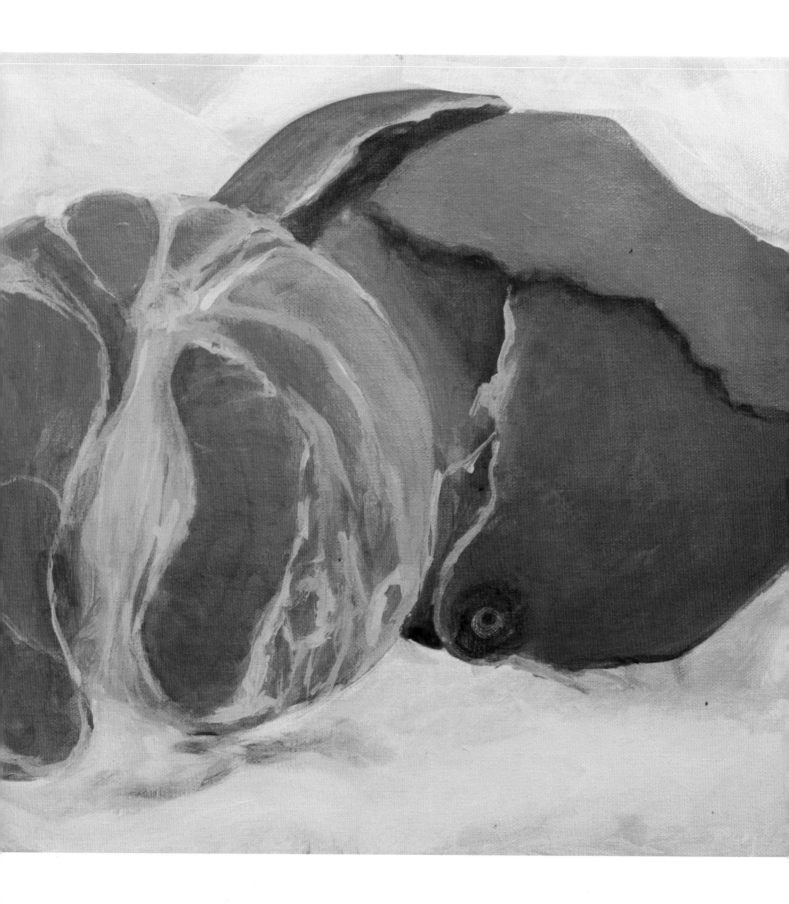

ACKNOWLEDGMENTS

Thanks to my editor, James Waller, who made my awkward sentences concise and my wandering points straight. He urged me to speak as clearly with words as I knew how to with paint.

Thanks to Candace Raney for the start of this book and also for the book's name, *The Acrylic Painter*. Thank you Leila Porteous, for the patient and kind work you did in bringing the early draft of this book into a workable form. Also, thank you for your enthusiasm about my art. And thanks to Lisa Buch, who I am sure thought I was as deaf as a post at times. I really was listening. Thanks, too, to Patrick Barb and the editorial staff at Watson-Guptill Publications / Ten Speed Press, who brought this project to fruition.

More indirectly important to this book has been the fertile environment of New York City, where I have grown as an artist and shown and sold my work for over thirty years. The OK Harris Works of Art Gallery and its founder, Ivan Karp, provided me with an artistic home and, as Ivan always said, "found good homes for [my] paintings."

And thanks to the School of Visual Arts, where I have taught acrylic painting for over twenty years. The artistic energy of this unique school lent clarity and breadth of vision to this book. Putting visual concepts into words is a stretch, and I have found that teaching is one of the best ways to understand what happens when art happens.

Thanks, too, to Golden Artist Colors and the Princeton Art & Brush Co. for so generously allowing me to use photographs of their products. And special thanks to Jodi O'Dell and Mark Golden.

Finally, I would like to thank the artists who believed in this project and who waived permissions fees in order contribute their visual voices to this conversation with readers. They are Elizabeth Blau, Marcia Burtt, Davis Cone, Juan Escauriaza, Elena Goldstein, Simon Hennessey, Moses Hoskins, Ronnie Landfield, Tom Martin, Jennifer Anne Norman, Rod Penner, Larry Poons, Mel Prest, Elektra Rose, John Salt, and Jo Ellen Silberstein.

Opposite: Elektra Rose, *Orange & Peel Study*, 2009, acrylic on linen, 12 x 12 inches (30.5 x 30.5 cm). Courtesy of the artist.

INTRODUCTION

Before the 1950s, painters had to put up with the strong smells and potential toxicity of oil paints. With the introduction of acrylic paint—in which pigments are suspended in a plastic polymer emulsion—we were given a wonderful painting medium that offers all the joy of oils with few disadvantages.

Acrylic paint is extremely flexible—so much so that a viewer may not identify an acrylic painting as uniquely "acrylic" at all. Acrylics can mimic the transparency of watercolor, or the flatness of tempera or gouache. You can use them as glazes that delicately enhance solid color. With acrylics, you can create a buttery stroke that can change a painting's surface, imbuing it with the bold feel of oil paint impasto. You can make works that resemble Renaissance oil paintings—or that have the vigorous delight of abstract expressionism. Acrylics can serve as adhesives and varnishes for collages. And—who knows?—acrylics may even do things that have never been done until you invent them.

This book is not just about painting with acrylic paint (hence the inclusion of several works created in other mediums); it is also about the process of seeing, about coming up with visual ideas, and about the decision-making that's so important in creating art. In these pages, I provide a visual vocabulary for a language of art, and I explore a wide variety of ways to use this vocabulary when working with acrylic paint. In the pages ahead, I'll discuss the subtleties of lights and darks and all the variations in between. I'll talk about color, helping you to understand—and not fear or be intimidated by it. And I'll give you advice about how to get started on a painting and when to stop.

To begin with, I'll cover in detail the materials and tools you'll need—always keeping a balance between what's necessary to get started and the things that may be added as you progress. To help you grasp the whole of the art-making experience, I'll deconstruct the process of visual experience, looking at the elements from which a painting is built—and then guide you in constructing your own art from these elements. This will lead, in turn, to a discussion of color and then of techniques for using the acrylic medium. It's my hope that all these explorations will help you achieve your own vision as an acrylic painter.

Opposite: James Van Patten, *Once Upon a Time* (originally entitled *Time*) (detail), 1989-90, acrylic on linen, 48 x 72 inches (122 x 183 cm). Private Collection.

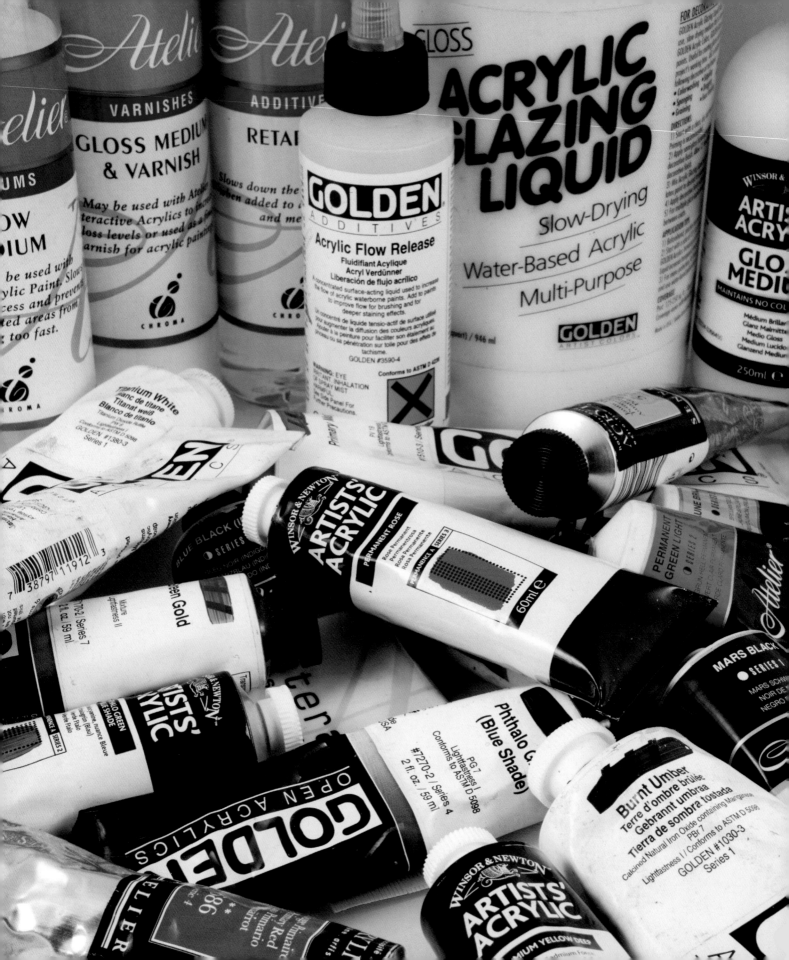

01 ACRYLIC PAINTS AND ADDITIVES

Gathering materials can be one of the more exhilarating parts of making a painting. An artist visiting an art supplies store is not unlike a chef wandering around a produce market looking for just the right ingredients and seasonings for a meal and then buying the utensils and vessels needed to bring the feast off. I begin this chapter with an examination of a substantial selection of the "ingredients and seasonings"—that is, the paints and additives—now available to the acrylic painter. I follow, in chapter 2, with a survey of the many tools—palettes, brushes, and other items—that you'll need to consider before getting down to work. In each case, I will specify the essentials you'll need to get started. In addition, I will discuss a variety of additional materials that, as you progress, can open new avenues of artistic exploration.

I've primarily based these chapters on my many years of using the materials discussed, though I've also drawn on the experience of painter colleagues and of many of my students. But this experience isn't the final word. Undoubtedly, some of you will go on to discover wonderful things about paints and other materials—things I've never even thought of. So please use my discussion as a set of suggestions rather than treating it as scripture.

TYPES OF ACRYLIC PAINT

Liquitex is the oldest brand of artists' acrylic paints. It now shares shelf space with several other manufacturers' lines.

Acrylic paint is a mixture of pigment (color), water, and agents that create different degrees of viscosity, or thickness. The starting point in manufacturing acrylic paint, regardless of the type or amount of pigment, is a fluid polymer emulsion: acrylic resin mixed with agents that make it water-soluble while in a fluid state but impervious to water when dry.

Acrylic paint is available in a number of different viscosities: heavy body, extra heavy body, light body, fluid, and so on. These designations have little to do with either the quality of the paint, its opacity, or its transparency. The basic state of the acrylic polymer emulsion that holds the pigment is fluid; the differences in body—that is, thickness or viscosity—result from various additives and fillers. The choice of body is up to the individual artist. Heavy body paints, however, are the most common choice and are the most widely available. These paints have the buttery texture traditionally associated with oil paint.

Heavy body acrylic paints come in tubes and jars. In my opinion, tubes are the more useful containers for the beginning acrylic painter since the paint tends to stay usable longer in tubes than in jars. In a jar, there's a small amount of air between the lid and the surface of the paint; because it's exposed to this air, the top layer of paint will dry and become unusable over time. (This is especially true of thicker, heavy body paint.)

COLOR MATTERS Pigment Load

Pigment load means just what it sounds like: it is the amount of pigment mixed into the paint relative to the amount of noncolor ingredients. Don't make the mistake of confusing a paint's thickness with its pigment load; there are heavy body paints with relatively light pigment load and light body paints with relatively high pigment load. As a general rule, the higher the price of a paint, the greater its pigment load and the fewer noncolor ingredients.

Various manufacturers' paints also differ in the fineness or coarseness of the ground pigment they contain. The fineness or coarseness of the pigment may affect the finish of paint when it dries, with coarser pigments resulting a finish that may be more matte than the soft gloss of traditional acrylics.

In acrylic paints, raw pigments like these are suspended in a polymer-and-water emulsion.

Fluid acrylic paints come in jars or bottles. As I'll explain later, I do not recommend fluid acrylics to beginners because of some difficulties they present and because of the specialized techniques they require. These applications are best left to more advanced painters. Beyond the heavy body and fluid acrylic paints (and the soft body, or light body, paint that is midway between the two), there are a number of specialized acrylic paints that I discuss beginning on page 17.

One common point of confusion—and source of apprehension—for the first-time painter is the classification of colors by group. Looking at the array of paints offered by any brand of acrylics, you'll notice that the colors are designated by "series"—Series A, Series B, and so on—and that these series differ, sometimes greatly, in price. The reason is simple: some colors cost more to make than others because of the differing costs of pigments, dyes, and other paint components. But relax. In this book, I'll recommend relatively inexpensive choices for you to start with. And I will approach color-mixing using just the three primary colors plus black and white. Later in your career as an acrylic painter, you may want to buy some of the more expensive colors to augment the colors you can mix from just five basic tubes of paint.

I'll talk in greater detail about which paints you, as a beginner, should buy in the section on setting up a palette, beginning on page 32. In the meantime, though, let's take a look at some of the different types and brands of acrylic paint. This is important, since you may find yourself overwhelmed by the huge variety of acrylics you'll find on sale at any better art supplies shop.

HEAVY BODY ACRYLICS

As I've said, I recommend that you work with heavy body acrylics to begin with. When it comes to choosing colors, don't be beguiled by all those beautiful colors just begging to come home with you. Start out with a simple palette—that is, a selection of colors from which you can mix many other colors. One possible palette consists of the following five colors: primary red, primary yellow, and primary cyan (i.e., blue), carbon black, and titanium white. An alternative is this group of seven: hansa yellow opaque, pyrrole red, quinacridone magenta, phthalo blue (G.S./green shade), phthalo green (B.S./blue shade), titanium white, and black. Or if you would like to use just a three-color mixing method and a slow-drying paint, the Golden OPEN line offers a "Try Color" starter set of tubes of Bismuth Vanadate Yellow, Phthalo Blue (G.S.), and Quinacridone Magenta. Decide which form of heavy body paint you want to use—standard quick-drying, slow-drying, or reworkable (all discussed later in this chapter)—and don't be afraid to ask questions of the art supplies store's staff.

Golden Artist Colors' heavy body acrylics are available in virtually all art supplies shops as pictured in this typical installation of Golden Acrylics.

Here is an example of a typical opacity rating on the back of a tube of paint.

Holbein's lines of acrylic paints are well regarded.

The brand you choose does count. When comparing the price of the same color from one brand to another, always remember: You get what you pay for. Not all acrylic paint is created equal, and some of the less-expensive paints are watery or have poor pigment/color load, meaning you may have to use more paint to reach the color intensity you are trying to achieve. With that in mind, here's some information on a few of the brands of heavy body paints you're likely to encounter.

Golden Artist Colors

I admit to a personal bias: Golden Artist Colors acrylic paint is the paint that I have primarily used for the past thirty years, and I consider Golden's heavy body paint the gold standard for both professional and nonprofessional painters. Its consistency of texture and color from tube to tube, from year to year, enters into my choice. Up until the last few years, I used a large number of colors, sometimes putting out over fifty different "out of the tube" unmixed hues on my palette, trying for as much color intensity as possible. The consistency from one paint tube to the next was always perfect.

Golden also makes acrylic paints in fluid forms that have about the same pigment load as its heavy body acrylics. I use the company's fluid paints in combination with its heavy body paints to mix thinner, wash-like colors as base coats for large, continuous-colored passages like sky or water in a landscape.

One other reason I developed this preference for Golden is the company's accessibility. Not only can I find this brand wherever I travel, but Golden's support staff welcomes questions on any paint problem I may get myself into in the studio. They even offer this service to artists using other brands of acrylic paint! Golden will also make personal formulations of paint to fit an artist's individual needs, and it provides unique paint formulations for art conservators restoring surfaces on paintings hundreds of years old. Golden Artist Colors is employee owned, and many of its staff people are themselves painters. There is even a foundation started by the Golden family that, since 2012, has run an artist-in-residence program, complete with living and studio space on a property near the company's central New York State headquarters.

Liquitex

Liquitex was the first brand of acrylic paint I ever used—and was, in fact, the only game in town for acrylic painters in the late 1950s and early '60s. It is still a marvelous, high-quality paint. But though I still hold Liquitex (now owned by the British-based art supplies company ColArt) in high regard, it has been my experience that its paints are not quite as consistent in texture and viscosity as Golden's. Occasionally, I have found Liquitex paint runny when squeezed out of the tube, and I also have had paint dry up even though the tube was tightly capped.

COLOR MATTERS "Student Grade" Paints

Art students, whether high school, college, or art school students, often don't have much money. To accommodate their tight budgets, several paint manufacturers make lines of student grade paints, which are significantly cheaper than their other lines. But, of course, you get what you pay for: these paints are cheaper because they contain less pigment and more filler, which means you can't achieve the depth or richness of color possible with artist grade paints. As a general rule, you should avoid the student grade lines even if you're a beginner, because you're unlikely to be as happy with the results of your work as you would be if you used better paints.

That said, some student grade lines are superior to others. These have an above-average pigment load for student grade paints and provide a good starting place for a person wanting a prepackaged group of colors. The Utrecht five-tube set consists of Titanium White, Ivory Black, Quinacridone Red, Hansa Yellow Pale, and Phalo Blue-Green Shade. Though I have referred to this as a student grade paint it is the standard Utrecht formulation that they sell as competitive grade paint to other middle-to high-grade paint like Liquitex or Golden Heavy Body. This five-tube set is available for under $30.00, a value stores advertise as being worth over $50.00 list price.

The Swiss company Lascaux is associated with the highest-quality—and is among the most expensive—acrylic paints, but Lascaux also makes a student grade paint, called Lascaux Studio, which comes in plastic squeeze bottles. Lascaux Studio paints are a good choice for beginners, if you can afford them—because although they're cheaper than the company's top-of-the-line Lascaux Artist colors, they're more expensive than other student grade paints. The squeeze bottle can reduce the shelf life of the paint because of the amount of air left in the bottle as the paint is used.

Finally, there's Liquitex BASICS, a line that is less expensive per ounce than Liquitex's professional line. This group of colors is marketed to people who want to try painting for the first time—not just students, but hobbyists who don't want to invest a lot of money in something they may not stick with but would like to try.

If you are considering buying student or other lesser-grade paints, the only guideline I recommend is that you shop carefully, including reading online reviews of the products. But the best way to save money while ensuring the best possible result is to begin with a very limited palette of top-quality paints.

The Utrecht five-tube box "Color Theory Set" is an acceptable starter set of student grade acrylics.

Other Heavy Body Acrylics

You can find Golden and Liquitex paints in virtually every art supplies store. In addition, there are a number of other manufacturers that make high-quality heavy body paints worth mentioning here, though they may be difficult to come by except in big art supplies stores in larger metropolitan areas (or online). Among the less well known companies is Sennelier, a premium-quality acrylics company with an extended color offering consisting of 120 colors. This company advertises a high pigment load and a consistency close to that of oil paint. A fine paint company also not well known is the Old Holland New Masters Classic Acrylics line, which claims the largest selection of acrylic colors that I have come across: 136, with an additional 32 that are iridescent or metallic.

And the Japanese art-materials manufacturer Holbein is known for its superb reformulated acrylic paint line called simply Heavy Body rather than its former name Acryla. The paint's new formula has a somewhat longer open time, but nowhere as long as that of Golden Open. It is also slightly more glossy than its predecessor, Acryla. I have always been impressed by the variety of colors—especially the range of blues, purples, and greens, with which I've had wonderful success—and by the luminosity of these paints. Some Holbein colors are unique

I used Golden OPEN acrylics for my painting *Stick in the Mud*.

James Van Patten, *Stick in the Mud*, 2010, acrylic on linen, 48 x 48 inches (122 x 122 cm). Courtesy of Plus One Gallery, London.

and not made by any other company. The colors whose names begin with the word *Compose* (pronounced COM-pose; for example, compose violet) are exceptionally intense and remain vivid whether used at full strength or mixed with other colors. (These colors are also somewhat pricey.)

"OPEN" ACRYLICS

Compared to traditional oil-based paints, most polymer-based acrylic paints dry very quickly. On the one hand, that is beneficial, since a surface painted with acrylic can be dry to the touch in as little as half an hour. This makes it easier for you to transport a just-painted canvas or panel without risking damage, and it allows you within a very short period of time to paint over a color without smearing it or mixing it with the color you're laying on top.

But this quick drying time also has serious drawbacks, which have bothered artists ever since acrylics were first introduced. It means, for example, that a painted surface will remain "workable" for relatively few minutes. And if you're working from a dry palette (see page 32), the paint on that palette will become rubbery and then hard and unusable within a short period of time.

Luckily, a few manufacturers of acrylic paint have seriously tackled this drying-time problem, creating lines of slower-drying acrylics. This extended period of workability is commonly called open time, because these paints don't lock down into unworkable hardness nearly as quickly as ordinary acrylics. One of these is the Atelier Interactive line from the Australian company Chroma; another is the OPEN line from the American company Golden Artist Colors. Let's examine these two lines in a bit more detail.

Atelier Interactive

Chroma's Atelier Interactive line is a brand-new slant on acrylics. Besides featuring several new colors as well as new additive fluids that change the properties of the paint, Atelier Interactive is the first commonly available acrylic that lets you bring the paint "back to life." Though acrylic paint is soluble in water, it usually becomes impervious to water once it's dry to the touch. But with Atelier Interactive paints, a painted area can, for a few hours, be brought back to life with water from a spray bottle or by a brush charged just with water, making blending from light to dark or softening an overly crisp passage easy to do. This ability to "reawaken" paint is something that painters who use acrylics have long wished for. The time during which you can reopen the paint can be extended for days using an additive called Atelier Unlocking Formula. You can also slow the paint's drying time even further with the addition of the company's retarder. (This will dilute the paint, compromising its covering properties slightly, much like water itself does.) If, however, there's a passage that you want to dry more quickly, you can achieve this by using the Atelier Fast Medium/Fixer.

One thing I really like about Atelier Interactive's line is that it offers six different blacks—allowing you to achieve great subtlety in very dark colors.

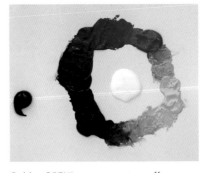

Golden OPEN's starter set, top, offers a "modern" color palette, including Hansa Yellow, Pyrrole Red, Quinacridone Magenta, Phthalo Blue (Green Shade), and Phthalo Green (Blue Shade), plus Titanium White. To complete the palette, add a tube of black. For more information, see page 11.

Acrylic paints in general undergo a color shift as they dry, appearing darker when dry than they did when still wet. This shift occurs because virtually all of the acrylic emulsions that carry pigment are milky, whitish fluids that become transparent when dry. When that milky-to-transparent change happens, the whitish component disappears, and the color appears to darken.

A number of manufacturers now offer coarse-pigment paints that dry to a flat matte finish, claiming that no such color shift occurs with these paints. I have found, however, that there is some color shift with even the most absolutely matte paints. Granted, it is subtle, but it still must be considered when you mix paint to a specific color.

Chroma, for example, now offers a line called Absolute Matte, claiming that these paints have no shift in color from wet to dry because of the matte finish when dry. And Holbein has recently joined the group of brands offering colors that advertise themselves as undergoing no color shift. According to promotional materials, Holbein Mat Acrylic is "characterized by its vivid mat tone and unique texture derived by coarse particles." At the time of this writing, this new matte paint was available in only thirty-six colors. It should be noted that matte (non-shiny) paints in general may contain a smaller amount of acrylic polymer than more satiny formulations, meaning that these paints' adhering property may be slightly compromised.

Winsor & Newton, one of the world's oldest and most respected art-materials manufacturers, has recently reformulated its professional grade acrylic paint to have a longer open time and less of a color shift from wet to dry. The company claims that its acrylic paint is different from any other because the acrylic base is completely clear rather than milky.

I was skeptical, so I did my own test, comparing Winsor & Newton's cerulean blue hue to three other cerulean blues from other manufacturers: Atelier Interactive and Golden's heavy body and OPEN lines. As you can see from the top left photos, I found that, as promised, Winsor & Newton's paint underwent no color shift from wet to dry. I am now a believer.

By the way, I also discovered that although Winsor & Newton's paint does dry more slowly than the company's old formulation, it wasn't open nearly as long as the Golden OPEN line. If you want to work with Winsor & Newton but open time is an issue, I strongly suggest mixing the company's Slow Drying Medium, shown left, with your paint.

I tested the wet-to-dry color shift of four cerulean blues—from Atelier Interactive, Golden heavy body, Golden OPEN, and Winsor & Newton—and found that, as advertised, the Winsor & Newton paint underwent little to no discernible shift when drying. Note that all three of the other manufacturers' paints pictured here are slightly darker, both wet and dry, than the Winsor & Newton sample. Though colors are very similar from brand to brand, there is no absolute industry standard.

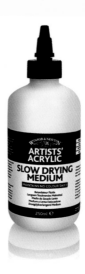

Winsor & Newton's Slow Drying Medium increases the open time of its professional grade acrylic paint.

These qualities don't make Atelier Interactive as forgiving or easy to rework as oil paint, but I would say that Interactive is significantly different from any other acrylic paint that I have ever used. One caution, based on my own experience: Thick paint dries more slowly than thin paint. When painting, I thin my paints considerably, which reduces the amount of time that Interactive (or any other paint) may remain open or workable. Sold in tubes, Atelier Interactive paint is slightly less firm than many other acrylic paints, but not at all runny.

Golden OPEN

For thirty-plus years, Golden Artist Colors has taken the lead as an acrylic paint innovator. With its Golden OPEN line, introduced in 2008, the company has addressed the problem of acrylics' fast drying time. Because Golden OPEN allows for easy blending and shading—a necessary property if you are trying to create an illusion of reality—realist painters like me now have an alternative to the various tricks for blending and shading regular acrylic paints that have been developed over time. Golden OPEN paints enable you to do everything you can do with Atelier Interactive, including reopening the paints. This means that up until twelve hours after application, you can bring the paint back to life—and work it just like fresh wet paint—using a damp brush. In my experience, the reopening of Golden OPEN is more reliable than Chroma Atelier Interactive. Moreover, it is possible to glaze over the dry-to-the-touch paint and to manipulate the glaze, achieving blending or shading with the paint underneath without any fear of the paint drying on the palette or the painting before the passage is satisfactorily completed.

On a dry palette, Golden OPEN colors can remain workable for a month or more if sealed in an airtight box between sessions.

The table below, adapted from Golden's promotional materials, compares the drying times of Golden OPEN, Golden heavy body (HB), and a half-and-half (1:1) mixture of the two paints. To put this comparison in real-life terms, imagine two artists working on similar pieces. One uses regular heavy body acrylic paint and the other uses Golden OPEN. OPEN acrylics give the latter artist up to three hours to work any area of the painting, until it is just the way she wants it. The artist working on the other canvas has just ten minutes until the paint is dry and can no longer be blended. Further, the artist working with the OPEN paint can come back to the painting ten or eleven hours later and correct a passage on the nearly dry-to-the-touch painting. She only needs to dampen her brush to reopen the passage and continue painting until she is satisfied.

	Wet	Workable	Can still be reopened	Touch dry	Locked down
OPEN acrylics	30–60 min.	1–3 hrs.	~12 hrs.	24+ hrs.	14+ days
Heavy body acrylics	5 min.	~10 min.	n/a	~30 min.	3+ days
1:1 OPEN and heavy body	10–20 min.	15–30 min.	1–2 hrs.	3–5 hrs.	10+ days

COLOR MATTERS Reducing Toxicity, Improving Stability

A noteworthy development in acrylic paints is the reformulation of traditional colors that may reduce the need for some of the classical pigments, some of which—for example, cadmium red, orange, and yellow—are toxic and others of which are simply unstable when mixed with an acrylic polymer vehicle. (This instability affects both the character of the paint, which may grow rubbery in the tube, and the color, which may change over time.)

These new formulations replace the toxic colors, making painting less hazardous. Golden, for example, has recently introduced a yellow (bismuth vanadate yellow) that has the intensity and opacity of cadmium yellow light but is nontoxic. Also, the range of colors of acrylic paints is increasing: You now see paints in traditional colors that have until recently only been available in oils. You can identify these colors, which have been achieved by using synthetic composites rather than traditional pigments, because the word *hue* appears after the color name, as in alizarin crimson hue or Prussian blue hue.

Golden's Prussian blue hue is one of the newer acrylic colors previously available only in oils.

If you choose to use a dry palette (see page 32), you will gain even more time if you keep that dry palette in an airtight box, such as Masterson's Artist Palette Seal. I recently found that I could keep paint open and workable for even longer than a month this way.

From here on, the discussion of acrylic paints becomes a bit more specialized—not necessarily the place for a beginning artist to start, but useful to know about.

FLUID ACRYLICS

Nowadays, very young artists—still in elementary school—often first try their hand at painting using fluid acrylic paints. These student grade liquid acrylic paints have largely replaced the tempera colors that were the art-class standard in earlier times. This is not necessarily a good thing: Once dry, the paint is quite permanent and can ruin children's clothes. And there is also the problem of how fast the paint dries, which can be frustrating to a child returning to a color mixed only a short time before to find that it is dry and cannot be made wet again, unlike the tempera paint that once was the norm for classroom use.

The kind of painting that most adults hope to do is, of course, different from the simple, stylized picture-making of childhood. And there is a range of better grade fluid acrylics produced for the professional artists' market. But before I say any more about these paints, I should restate that I do not generally recommend fluid acrylics as a beginner's medium. Most fluid acrylic paint is not only very fast-drying, but because it is runny, it is hard to control. It has a tendency to drip, and will migrate on any surface you use as a palette and then dry before you have a chance to mix or manipulate it. If you use it on a wet palette (see page 33), it will exaggerate the migration and magnify the difficulty any artist experiences in maintaining an orderly palette.

Fluid acrylics like this Paynes gray from Golden are much runnier than heavy body paints.

COLOR MATTERS Another Option: Soft Body Acrylics

Liquitex offers a paint option that, viscosity-wise, is midway between heavy body and fluid. Liquitex's Soft Body line is much runnier than heavy body paint but not truly fluid. A warning is in order: it is all too easy to pick up a tube of this paint thinking it is a heavy body paint only to find out after you've opened it that it is not, so read the label carefully. If you are mixing paint that you intend to apply in a fairly thin way, this honey-thick paint may be a good choice. It also has a better self-leveling quality than fluid acrylic, meaning it's not as likely to produce the ridges that are a major drawback of fluid acrylics.

All that said, there are times that fluid acrylic paint is the best choice. Fluid acrylics are a must for artists who want to cover large areas with solid or fairly homogeneous colors using a quantity mixed in a container. Fluid acrylic colors are also useful for touching up passages that have been painted earlier.

There are a number of quite inexpensive ways of exploring liquid acrylics as a possible medium. Some fluid acrylics are "house branded" paints sold by major art supplies chains—for example, Dick Blick, which offers its Blickrylic Student Acrylics in thirty colors, including metallics and fluorescents. One product in this low-priced line is Blick's 6-Pack Mixing Color Set, with six flip-top pint bottles in a convenient carrying carton. The colors are chrome yellow, magenta, ultramarine blue, phthalo blue, Mars black, and titanium white, and there's a color-mixing guide included that shows you how to achieve a range of colors from this very simple palette. Always bear in mind, though, that you'll experience the problem of too-fast drying time—and color migration, if you're using a wet palette—with these paints.

The art supplies chain Jerry's Artarama (and its online store, jerrysartarama. com) carries several exclusive brands of fluid acrylic paint, including LUKAS CRYL (imported from Germany) and Matisse Flow (imported from Australia). Some of my painter friends who insist on quality find these fluid colors—which

Fluid acrylics (especially Paynes gray) were used to cover large passages of fairly homogenous color in my painting *First Look at Blueberry Lake.*

James Van Patten, *First Look at Blueberry Lake,* 1987, acrylic on linen, 48 x 72 inches (122 x 183 cm). Private collection, Switzerland.

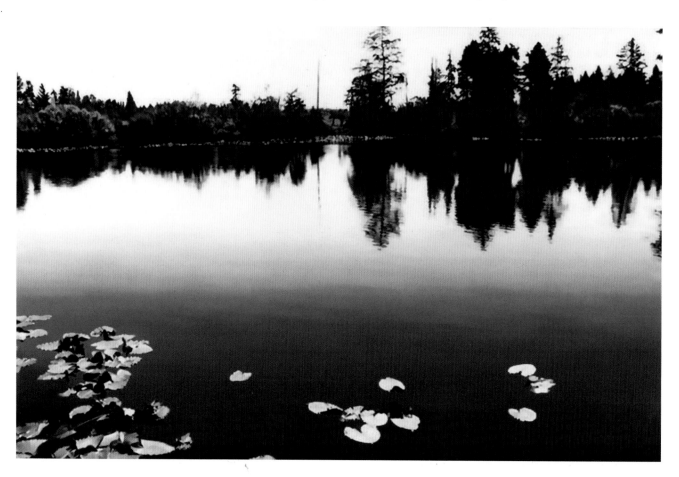

are a bit more expensive than the Blick's brand—more than satisfactory. They're especially useful for the abstract painter using large passages of vibrant color working against optically tense line elements. Work like this might formerly have been possible in another medium, but it was acrylic paint—especially fluid and soft body acrylic paint and acrylic gouache (see page 17)—that inspired this development in abstract art.

A quick mention should be made of a new line of fluid acrylic paint, called High Flow, recently introduced by Golden. This superfluid paint has exceptionally good self-leveling properties (meaning you won't get the ridges that can appear with undiluted fluid acrylics) and many applications beyond brushing alone—including use in acrylic markers, drawing pens, and airbrushes.

You should probably use fluid colors on a wet palette (see page 33) because they dry so quickly. But you must work with small amounts confined to small areas because the runny paint is so apt to migrate into the next color on a wet palette. An alternative is to keep colors you have mixed in resealable jars or plastic cups with lids. That's what I do in my own studio practice when using these colors for large areas of comparatively solid color with some blending. In the painting opposite, I started at the bottom with a mix of Paynes gray and phthalo blue, and a near-white at the top of the water area. Then I mixed a number of tones for the blend between the dark starting point and light ending point. The process involved constantly misting the whole area to keep it moist but not runny and working with several fan brushes, each charged with a separate color tone. This was not easy. I needed to work and rework it several times until I was happy. (There are still a few spots that I wish were different, but I won't point them out!)

ARTFUL TIP Avoiding Ridged Brushstrokes

One problem with fluid acrylics is that, if used undiluted, the paint will show ridged brushstroke lines because of its fast drying time and poor flow properties. You can offset this problem, shown in the photo on the right, by using "Van Patten's solution" (see page 22)—spraying the solution on the painting's surface, mixing it with the paint, or dampening your brush with it before charging the brush with the fluid acrylic. It is always a good idea to test any paint to observe how it flows from the brush, whether the brushstrokes will be apparent on the painted surface, how opaque or transparent it is, and how much color shift it undergoes when drying. You may also solve the brush-ridge and brush-drag problem by adding a small amount of Golden OPEN Thinner or a small amount of any surface-tension breaker, such as Liquitex Flow-Aid (see page 21).

When undiluted fluid acrylics dry, they can leave undesirable ridged brushstrokes, as seen here.

Unlike the ink markers that have been available for decades, the new acrylic markers dispense paint—which, like any acrylic paint, is water-soluble when wet and impervious to water when dry. They may be used in any way that acrylic paint is used and in places where markers could not be safely used before. In the past, ink markers created a real mess when used in acrylic paintings. They bled through layers of paint or faded away to nothing.

But the new acrylic markers' opacity is on a par with that of a heavy body color that's been thinned to the same consistency. Although the color may be somewhat translucent on the first coat, the opacity increases with successive passes. They would be a superb choice for underpainting, especially in a study with no halftones (see page 123), where the goal is only to create areas of dark and light, although it is also possible to blend them into halftones. And for painters using a hard-edge technique (see page 136), they are a miracle. In addition, they have virtually no odor and, unlike regular ink markers, release no toxic fumes. I began my own exploration of acrylic markers by using one to strengthen a line on a small painting, shown below. It did the job very well.

Acrylic markers are now made by a number of manufacturers: You'll probably find the Montana line—whose refillable markers feature nibs in four different sizes (0.7 mm, 2 mm, 4 mm, and 15 mm)—at your local art supplies shop. And the Liquitex brand has now gotten into the acrylic-marker game. Liquitex's markers, in fifty colors that mirror the colors of Liquitex's other lines of acrylic paint, come in two sizes: a 2 mm chisel nib (line width: 2-4 mm) and a 15 mm nib (line width: 8-15 mm). Replacement nibs are available. And Golden now offers empty markers in a variety of sizes that may be filled with the company's new High Flow line of superfluid paint and used like the other markers mentioned here.

Acrylic markers such as this line from Liquitex are a brand-new acrylic medium.

I first used an acrylic marker in my painting *Breakfast* (see page 112), using it to create the very straight turquoise line representing the edge of a glass tabletop that runs diagonally across the bottom of this detail.

SPECIALIZED ACRYLIC PAINTS

Beyond the heavy body (regular and open) and fluid acrylic paints discussed previously, there are a number of other types of acrylic paint on the market. Though you probably won't use these when you're just beginning, it's good to know something about them, especially since the acrylic medium lends itself so well to a kind of "cross-pollination": You can use all these different kinds of paint in combination, allowing you to move outside the boundaries when creating your artwork.

Acrylic Gouache

Acrylic gouaches such as the Acryla brand made by Holbein and the Acryl line from Turner fill a niche as flat, easily worked paints typically used in illustration requiring highly detailed rendering. But the uses of acrylic gouache aren't limited to illustration. You can also use it on canvas and other grounds for fine art projects intended for gallery display and permanent collections, where good archival properties are a necessity. Painter Peter Stroud used Turner Acryl Gouache for his abstract composition below.

Turner Acryl Gouache is the Jerry's Artarama store brand—the brand Peter Stroud used for the painting pictured below.

Peter Stroud, *Untitled*, 2005, acrylic gouache on canvas, 48 x 48 inches (122 x 122 cm). Collection of James Van Patten.

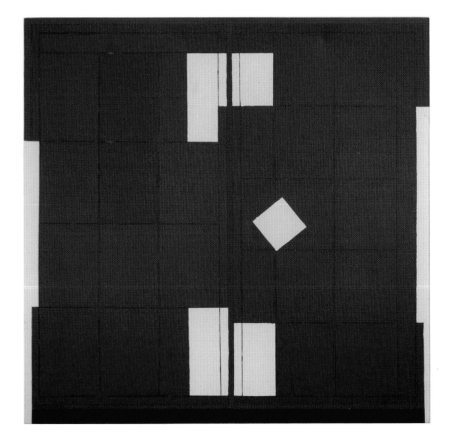

One of the only noticeable differences between acrylic gouache and regular acrylic artists' colors—besides the smaller size of the tubes it comes in (20 ml, or about two-thirds of an ounce, rather than the standard 2-ounce tube)—is that, like all high-quality gouaches, it has a matte finish when dry. An advantage of an acrylic gouache over other gouaches is that its surface is less fragile when completely dry and cured. Note that, unlike ordinary gouaches, acrylic gouaches generally do lock down and become entirely impervious to water when cured.

Acrylic Spray Paint

Liquitex Professional Spray Paint has multiple uses, including building smooth gradations of color.

High-quality acrylic spray paints are very different from the spray paints you'd find in a hardware store. They're formulated for artists: the colors aren't fugitive (meaning they won't separate from the underpainting), and the paints won't peel off the surfaces to which they're applied. One of the brands on the market, Liquitex Professional Spray Paint, combines the company's pigments with a water-based formulation that gives these paints the color brilliance, durability, and lightfastness (long-term stability when exposed to light) of Liquitex's other lines of acrylic paint. This low-odor aerosol vehicle is suitable for use in most environments, including indoors (if well ventilated), and is versatile enough to use on almost any ground, including canvas, wood, masonry, or even glass. It's also fully intermixable with other acrylic paint and dries to the same tough, permanent finish. This product would be appropriate for both beginning and more seasoned painters because of its ease of application and good results. Many times I've wanted to soften an area or to build a smooth gradation without the hassle of hours of painstaking blending, and these spray paints seem ideal for this purpose, as well as for building underpainted color gradations in expanses of sky and water. Note that when you're shopping for acrylic spray paints at art supplies stores, these paints are often kept under lock and key—a strategy, I guess, for keeping them out of the hands of young graffiti artists.

Airbrush Paints and Inks

It is worth discussing airbrush paints and inks briefly, to help you make your way through the multitude of products available. There are as many subtle differences between various acrylic airbrush paints—involving pigment load, color shift, and so on—as between all the other classifications of acrylic paint, from the very thickest to the most fluid. It's good to know a little about this, since you might someday want to try airbrushing, starting with a simple palette of primary colors.

Airbrush acrylics and inks are almost interchangeable, which is why I'm discussing them both together. But don't be confused: they are usually not the same thing as fluid acrylics. If a paint is not thin enough to use in a pen, it will not work in an airbrush. And if the paint's container does not mention airbrush and pen applications, it is probably the wrong choice for these purposes. Besides airbrush acrylics' finer liquid consistency, the most basic difference between them

It would take us too far afield from this book's purpose, I am not going to attempt to instruct you in airbrush selection or technique here, but let me give you just a few pointers.

Airbrushes are of two major types: single action and double action. Single-action brushes allow you to control only the amount of air going through the tool while in use; the amount of paint sprayed is determined by adjusting the airbrush before beginning to use it. The airbrush pictured top right is a double-action brush much like the one I use. The cup beside the device is the color source and is attached to the spray mechanism by simply plugging it into the hole in the side of the airbrush. By pressing down on the trigger, you can vary the amount of air released through the tip, and by pulling back on the trigger, you can increase the amount of paint drawn through the device.

The surprising thing about an airbrush is just how easy it is to learn to use one. My brother gave me one that he had used for thirty years, and after just a few hours of experimenting with it, I was making all sorts of lovely soft lines and blended shapes, at first on paper, then on illustration board, and finally on canvas. I would encourage anyone who has time to explore this device as an art-making tool to try it.

You can apply paint with an airbrush in a freehand way, or you can use stencils to control which areas of the ground (paper, canvas, or whatever) get painted. There is a lot of crossover between these techniques, with artists like Tom Martin using both (see photos below). It is also possible to use plastic film, paper, or the masking material called frisket to cover areas you don't want painted, as shown in the photo on the right.

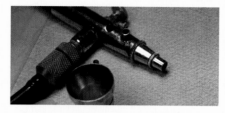

Double-action airbrushes permit you to control both the force of the airflow and the amount of paint being sprayed at any moment.

Photo courtesy of Golden Artist Colors.

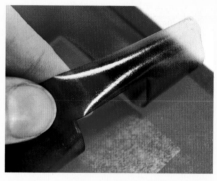

When airbrushing, you can mask areas that you don't want the paint to cover with a material called frisket, peeling it off after the paint has dried.

Photo courtesy of Golden Artist Colors.

The English hyperrealist painter Tom Martin uses both stencils and freehand airbrush technique when developing his paintings. The photos at left show three stages in the process of making his painting *A Wok Full*, with the completed painting shown lower right. The small, round metal objects you see in the in-progress shots are actually magnets that Martin uses to hold the acetate stencils in place. However unusual it may seem, Martin's technique is really much like that of any painter, slowly building and layering paint until the image reveals itself. But instead of painting with a brush with hair, he uses a brush with air.

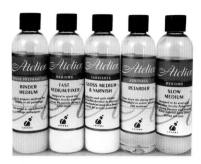

Here's a lineup of some of the additives I use most frequently: Atelier Binder Medium, Fast Medium/Fixer, Gloss Medium & Varnish, Retarder, and Slow Medium. This is a random group from just one company. There are similar additives from each of the acrylic paint manufacturers.

and other acrylics is that airbrush colors dry somewhat more slowly, giving you time to properly clean residue out of the spraying tool (or pen). Airbrush acrylics also have a self-leveling property, meaning, as mentioned previously, that you wouldn't get the ridges that can appear with undiluted fluid acrylics even were you to apply airbrush paint with a regular brush directly from the bottle.

Opacity and transparency are especially important properties to consider when using airbrush paints, whether you're using them in an airbrush or with an ordinary brush. Opaque and transparent colors should both be used in tandem, applying one coat over another, to achieve smooth gradations when shading. It may take quite a bit of experimentation to achieve the effect you want.

In 2013, Golden Artist Colors introduced a full line of colors called High Flow Acrylics, replacing their former airbrush line. Available in 1-, 4-, and 16-ounce bottles as well as two convenient sets of 1-ounce bottles (sets of ten transparent colors and of ten assorted colors), these paints are superversatile, suitable for regular brushes, pens, and airbrushes and for filling acrylic markers. (For more on markers, see the sidebar on page 16.)

Holbein's Aeroflash line is an airbrush-specific formulation that has the same brilliant color palette of Holbein's other acrylic paint formulations. These paints, which you can buy individually or in a set of twelve basic colors, have a somewhat slower drying time. Their light consistency makes for easy mixing and application, and although Aeroflash is intended for airbrushing, it also works nicely in situations where you need a thin, high-pigment-load paint with a comparatively slow drying time.

And while I'm on the subject of airbrush colors, I should mention that two airbrush manufacturers—Badger and Iwata—produce their own, very respectable acrylic paint lines. Everything I've heard about these lines is positive, and the fact that Badger and Iwata put their names on acrylic products is itself an important endorsement. These two leaders in the airbrush industry would only back a product that would not damage their fine tools. Iwata's Com-Art line is especially noteworthy for its Photo Gray Set of ten bottles of hard-to-find neutral tones.

Liquitex Professional Acrylic Ink, which comes in a range of thirty colors, is actually an extremely fluid acrylic paint made with superfine pigments suspended in an acrylic emulsion thin enough that you can use it just like ink, with a brush or pen—though it is also specified as appropriate for airbrush. The Liquitex line includes both opaque and transparent colors, but you must refer to the specifications on each bottle to find out whether the color is opaque or transparent. As with any acrylic color, you should test these inks on a separate surface before putting them to use in an artwork.

ADDITIVES

Wander into the acrylic paint aisle of any big art supplies store and you'll be greeted not only by the vast selection of paints offered by the various brands but by an incredible array of additives. These additives serve many purposes: there are retarders that make the paint dry more slowly; fast-drying additives, or fixers, that do just the opposite; flow enhancers that make the paint act "wetter"; and unlocking formulas that allow you to rework a painted surface that has dried (best used to remove or soften areas rather than bring paint back to life), as well as a wide range of mediums, glazing fluids, gels, pastes, and grounds.

Like many acrylic painters, I use some of these products constantly—the photo opposite shows a selection of additives from Chroma's Atelier line that just happened to be sitting on a shelf opposite my computer as I was writing this paragraph. As you progress as an acrylic painter, you'll likewise make use of at least some additives. The short list will probably include some type of retarding agent, a flow enhancer, a slow-drying gloss medium (probably a glazing liquid), and some type of fixing agent or fast-drying medium, especially if you use slower-drying paint. At the end of the painting process, you will also need a barrier coat and a varnish, but I'll deal with those elsewhere when we talk about finishing and presenting a painting (see page 152).

RETARDERS

Thirty years ago, when I began painting realist landscapes with acrylics, I found myself frustrated by my lack of control over this fast-drying paint. It seemed that whenever I went back to work on that one little spot or that big blended area or that fine line, the paint had already dried out—either on the painting itself or on the palette or, worst of all, on my brush. What could I do? Screaming and throwing things certainly didn't help! Remember, this was back in the days when slower-drying acrylics like the Atelier Interactive and Golden OPEN lines discussed earlier simply didn't exist.

Thankfully, I found that there were solutions to the fast-drying problem. For example, I could delay the drying-out process by using a spray bottle to mist the canvas and palette. Or I could use a retarding fluid as a brush-wetting agent prior to charging my brush. Or I could load my spray bottle with a mixture of water and a retarding agent. The essential ingredient in retarders is propylene glycol, which keeps anything it touches moist. (It is nontoxic, so you shouldn't be worried about using it.) I recommend either the retarder made by Golden, which though slightly cloudy in appearance contains no acrylic medium at all, or the one made by Atelier. No matter which you use, you'll want to dilute it with water in a 50/50 solution, and either spray it on a painted surface or dampen your brush with it before charging the brush with paint. In my opinion, you

Left: Atelier is just one of many brands offering retarding fluids that make acrylic paints dry more slowly.

Right: Liquitex Flow-Aid is a nonfoaming surfactant, meaning that it breaks the surface tension in water molecules.

Golden's OPEN Thinner provides a great way of mixing paint thinly without causing it to become drippy. It's like "thick water."

should not mix it directly with paint, which can make the drying time extremely unpredictable. (The obvious alternative to using a retarder is to work with one of the open acrylic paints discussed earlier in this chapter, which are, in fact, mixtures of acrylic paint and retarding agents. Their advantage is that the mixture is consistent, so the various areas of your painting will all dry at the same rate.)

FLOW ENHANCERS

Water can sometimes use a little help. It can become "wetter" and flow more easily if "enhanced." As you probably already know, water has a property called surface tension, which holds drops of water together and prevents them from dispersing—as demonstrated, for example, by the droplets that remain on the hood of a car after rain. What the additives known as flow enhancers do is to break this surface tension—in fact, it would be more accurate to call them surface-tension breakers. Enhancers are surfactants, like soap: if you introduce a bit of soap into a drop of water, the water becomes more diffuse because the soap molecules get in between the water molecules, breaking the bonds that hold them together.

ARTFUL TIP "Van Patten's Solution"

"Van Patten's Solution" solves two problems at once, slowing down drying time and making water wetter and more slippery, so there's no brush drag on a dry canvas. About thirty years ago, I developed a solution to acrylic paint's too-fast drying time and, simultaneously, to the problem of plain water's not being wet enough. I called it "Van Patten's Solution" and have used it ever since. The recipe is simple: 4 parts water to 3 parts retarder to 1 part flow enhancer. It's a nonpolymer wetting solution, meaning that the mixture has nothing in it that will form a bond or dry hard, so it behaves like "superwater." I dip an uncharged brush (without any paint or ordinary water on it) into the solution and then mix the color on the palette with the brush, charging the brush as I do so. The mixed color remains usable for many minutes, enabling me to blend paint, soften edges, move paint around on the canvas, or even wipe the paint off. The retarder is only part of what makes this mixture so effective; the flow enhancer makes the paint mix more readily and makes it easier to move the paint around the painting.

To be honest, using this mixture does sacrifice a little of acrylic paint's good qualities. It weakens the paint's polymer emulsion, at least until the paint is totally cured and not just dry to the touch. Eventually, there does come a point when the paint totally locks down, becoming impervious to water and resistant to scratches and scrapes.

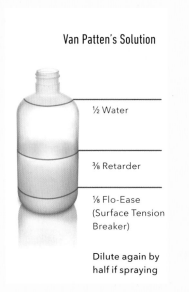

Van Patten's Solution

½ Water

⅜ Retarder

⅛ Flo-Ease (Surface Tension Breaker)

Dilute again by half if spraying

So enhancers make water more fluid—"wetter"—and therefore more efficient as a carrier for paint. Ordinarily, when you're working paint into a dry surface, whether canvas or paper, there can be some drag on the brush as it moves across the surface. Just dampening your brush with water will help somewhat. (It's almost instinctual to dampen a brush with water before charging it with paint.) But using a mixture of water and flow enhancer is better for reducing brush drag than water alone. As with all additives, the purpose is to make painting easier and more predictable, not to confuse. So if your paint is not doing what you want it to do, stop, identify what the problem is, and look for an additive that may help.

A number of manufacturers produce flow enhancers, which include Winsor & Newton's Flow Improver and Golden's Acrylic Flow Release. But Liquitex's Flow-Aid is the one I've found the most pleasant to use, especially when I've mixed it with water in a spray bottle. When spraying, the solution is aerosolized, so there's a chance that you'll inhale some of the flow enhancer. This is nothing to worry about, because the chemical is very benign. But a surface-tension breaker does an odd thing when you breathe it in: because it also breaks the surface tension of airborne droplets of water in your lungs, it can make you cough. I've found that the Liquitex product is a little less aggressive in this regard.

There are a number of other wetting fluids that work as a kind of "thick water," thinning the paint without making it watery or runny. The best of these fluids is Golden's OPEN Thinner, pictured in the top left photo. You may mix it directly with the color, providing an agent that will make the paint thinner and very slippery in application while also slowing the drying time. I use this excellent product in my work not only with the Golden OPEN line of paints but as a wetting alternative to water when working with any other brand of acrylic paint.

MEDIUMS

The simplest and most convenient way to think about acrylic mediums is as color-free acrylic paints. Oil painters use their mediums as wetting agents on their brushes before charging the brushes with paint; acrylic painters, however, use their mediums in a much broader variety of ways. Mediums have been around since acrylic paints first came onto the scene, but as the variety of such products has increased, mediums have really changed the way that painters paint—opening whole new avenues of artistic expression.

You can use acrylic mediums to make the applied paint glossier or less glossy. They can alter the viscosity, or thickness, of the paint. (The extra-viscous mediums called gels as well as compounds containing textural enhancers are discussed separately, page 27.) Some mediums are useful for building collages

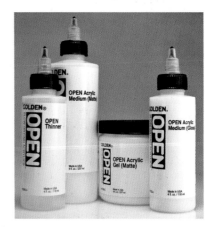

Golden OPEN's mediums as well as their more viscous gels come in two levels of luster: gloss and matte.

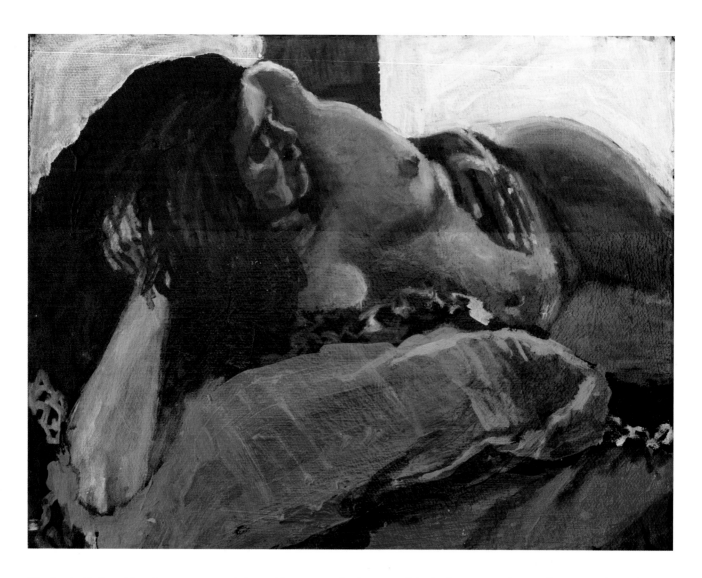

Whether the final varnish is glossy or matte will affect the look of a painting, as can be seen in this sketch of mine, the upper half of which is coated with matte varnish and the lower half with gloss.

James Van Patten, *Color Sketch of a Nude*, 1995, acrylic on canvas, 8 x 10 inches (20.5 x 25.4 cm). Collection of the artist.

with paper and other materials. And some may be used as a varnish or a barrier coat prior to varnishing. The mediums known as glazing liquids are the primary vehicles for building glazes—which I'll discuss in more detail in the following section on glazing fluids. And recently, mediums have been developed that alter drying time, slowing it down or speeding it up.

Most acrylic mediums come in several versions: gloss, semi-gloss (or satin), and matte. The shininess (or lack thereof) of a painted surface affects the perceived intensity of a color. For example, a high-gloss medium used on a dark passage will make that passage appear deeper than the same color with a matte-medium surface. The reason is that the surface of a matte area traps and diffuses light slightly, while a glossy area only reflects the light source and doesn't trap light and spread it out across the surface. The character of the surface of a painting is a matter of personal taste. Using a medium as a wetting

agent while working a painting can make passages shiny or matte, but the final protective coats of varnish, discussed at the end of this book (see page 152), will give the painting its final overall look. Of course, as already discussed, if you want a matte finish you might also choose one of the paints specially formulated to look matte when dry—for example, Golden's Heavy Body Matte, Chroma's Absolute Matte, Holbein's Mat, or any of the acrylic gouaches.

The two types of palettes discussed at the beginning of the next chapter will determine to some extent how you use mediums. If you choose a wet palette, the paint will be relatively thin in body because of the constant dampening effect of the surface of the palette. This will mean that bringing a brush precharged with a medium to the paint may make the paint too dilute to cover well. But if you work from a dry palette, you will almost always want to have a brush precharged or dampened with medium before you dip it into the paint.

There is another way of using mediums that requires more work and the results of which can be somewhat unpredictable. This is to carefully premix each of the colors you'll be using with the medium of your choice to obtain the level of shininess or flatness you want. You should do this in sealable plastic containers, then set up your palette using only these premixed flat or gloss colors. But if you want all your colors to have the same degree of luster as you're using them, I would instead recommend going with one of the paints that is already flat or glossy. And remember, no matter which paints or mediums you use, it's really the final varnish that will determine the finish of your painting.

The lines of acrylic paints that have been reformulated to increase their "open" time—Golden OPEN, the Atelier line from Chroma, and Winsor & Newton's Artists' Acrylic—all also offer mediums that deserve mention. Since all brands of acrylic paint and accompanying mediums and gels are intermixable (Golden's products may be mixed with Winsor & Newton's, for example), it's possible to use a slow-drying medium with an ordinary, fast-drying acrylic paint or to use a fast-drying medium such as Atelier's Fast Medium/Fixer to seal a layer of any acrylic paint so that you may paint over it almost immediately.

GLAZING FLUIDS

Glazing is a universal technique in painting, whether representational or abstract. I will talk at some length about glazing when I cover painting technique (see page 139), but briefly, glazing means to layer translucent or transparent colors to create a rich, jewel-like effect. There are many, many types of glazing and a wide variety of varnishes and thinning preparations that can be used for the purpose. But, here, let's look at the varnish-like, slightly slower-drying glazing liquids, such as those made by Golden, Winsor & Newton, and Liquitex. They're available in different degrees of gloss, but it's best to begin experimenting with one of the glossier fluids.

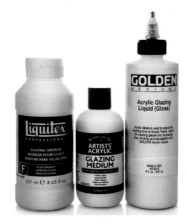

Glazing fluids, like the three examples shown here, are slow-drying, high-gloss mediums that lose their milkiness very quickly. They can be used to brighten up colors or mixed with color and then brushed over colors already on a painting's surface, enhancing them.

In this four-panel piece, Norman uses gel to both obscure and reveal the embedded layers of paint, tantalizing the viewer.

Jennifer Anne Norman, *Magnanimous National Enclave,* 2011, acrylic paint and acrylic gel on canvas, four pieces, each approximately 10 x 10 x 1¾ inches (25.4 x 25.4 x 4.4 cm). Courtesy of the artist.

While working on an acrylic painting, you'll almost always notice that some areas become dull as they begin to dry while other areas may be quite shiny. I use a thin coat of the clear gloss version of Golden's glazing fluid to bring all the paint to the same level of shininess, so there's no unevenness in the look of the painted surface. This allows me to adjust the colors right away, because the glazing preparation is comparatively slow-drying and because it loses its whitish cast almost immediately. Since I prefer the surface of my finished work somewhat glossy, this gives me a glimpse of what the work's final state will look like. Some glazing products are also available in satin and matte versions, but care should be taken in using these, because they're not quite as transparent as the glossy glazing fluid and therefore may not work as well as previewing devices. When working with glazing liquids, you should always test their effects, either on a scrap or on a part of your work that you know will eventually be painted out.

GELS, PASTES, AND GROUNDS

You can mix acrylic gels with acrylic paints or use them to build undersurfaces to which color can then be applied. They are usually color-free—transparent or at least translucent with perhaps a whitish, light gray, or pale buff tone. Gels are usually used to increase an area's thickness, to provide an impasto effect that looks like thick oil-paint impasto, or perhaps to add a dimensional effect to a painted shape, almost like a bas-relief. There are gels that will make peaks and hold the shape of your brushstroke or the impression made by another shaping tool, not unlike the peaked swirls you make when frosting a cake. There are even gel compounds that have glass beads suspended in them. These create a surface that looks granular if covered with a coat of paint; if thinly applied over paint, they can create a surface reflection unlike any other gloss.

The several Golden gels pictured at right give you some idea of how gels can be put to use, but they don't really show how powerful the effects of gels can be in the context of real works of art. The pieces by Jennifer Anne Norman (opposite) are especially dramatic, because she uses gels to create layered, semitransparent objects that blur the line between painting and sculpture. These artworks don't present an illusion of three dimensions; they are, in fact, three-dimensional. The vast variety of gels now available offer truly unlimited possibilities when combined with color.

You may want to try some highly textured surface treatments or even to stretch the idea of painting into something sculptural. Besides textured gels, there are various types of pastes and grounds created for such purposes. Unlike gels, which are translucent, pastes and grounds are opaque and have the quality of other materials—for example, stone, plaster, or fiber. One intriguing paste, called crackle paste, creates the rather dramatic surface pictured left. Color may be added to any paste or ground, whether you use it as the ground for a painting or as a texture within a painting or collage.

One common use of gels is to create a greater volume of paint with the heavier viscosity required for an impasto technique. Here, Golden's Heavy Body paint is mixed with heavy matte gel at a ratio of about 1 part paint to 3 parts gel.

Image courtesy of Golden Artist Colors.

Here are just a few examples of the many gels made by Golden Artist Colors. In the top photo, Extra Heavy Semi-Gloss Gel, with Magenta added, has been laid over a striped ground to show its degree of opacity; also shown are Glass Bead Gel (with some blue paint applied, middle) and Pumice Gel (bottom).

Image courtesy of Golden Artist Colors.

Although it looks as if it may chip off, when allowed to cure, crackle paste provides a stable base on which to apply color.

Image courtesy of Golden Artist Colors.

When you apply paint to Golden's Absorbent Ground, it produces a surface effect much like that of wet, absorbent paper.

Image courtesy of Golden Artist Colors.

The word *ground*, by the way, may cause confusion for someone just beginning to explore the strange land of art supplies. That's because the term has two related but different meanings: it may refer (1) to the painting's support (the canvas or panel), or (2) to the surface on which the paint is laid. As used here, *ground* refers to a substance applied to the surface that changes its appearance and the way that paint interacts with it. A good example is Golden's Absorbent Ground, pictured bottom left, which produces a wet watercolor effect much like what you would expect from a very absorbent paper. All these products open new doors for the creative mind. Be aware that pastes and grounds are somewhat heavy, which means they will only work if applied to a rigid, stable base, so always test before you commit your time to an idea that may not work.

By the way, the ground that you are most likely to encounter is gesso, which is used to prime a canvas before painting. It's so common, and so important, that I discuss it separately, beginning on page 50.

ARTFUL TIP Painter Beware

Be forewarned that student grade acrylic colors and other cheaper acrylic paints will not work well when combined with gels or pastes. Less-expensive acrylics already have lots of fillers and extenders in the paint, so although the color may look okay unmixed, it will lose some of its saturation—that is, it will appear weaker—if mixed with a gel or paste. No matter what kind of acrylic paint you use, if you want to experiment with impasto, another highly textured application, or any effect you haven't tried before, it is always advisable to first experiment on a surface other than the painting in which you want to use it.

Jennifer Anne Norman's *Serotonin* is a "painting" of an entirely new sort. Acrylic paints are embedded in acrylic gel in this cubical form.

Jennifer Anne Norman, *Serotonin,* 2012, acrylic paint and acrylic gel on canvas, 12 x 12 x 12 inches (30.5 x 30.5 x 30.5 cm). Courtesy of the artist.

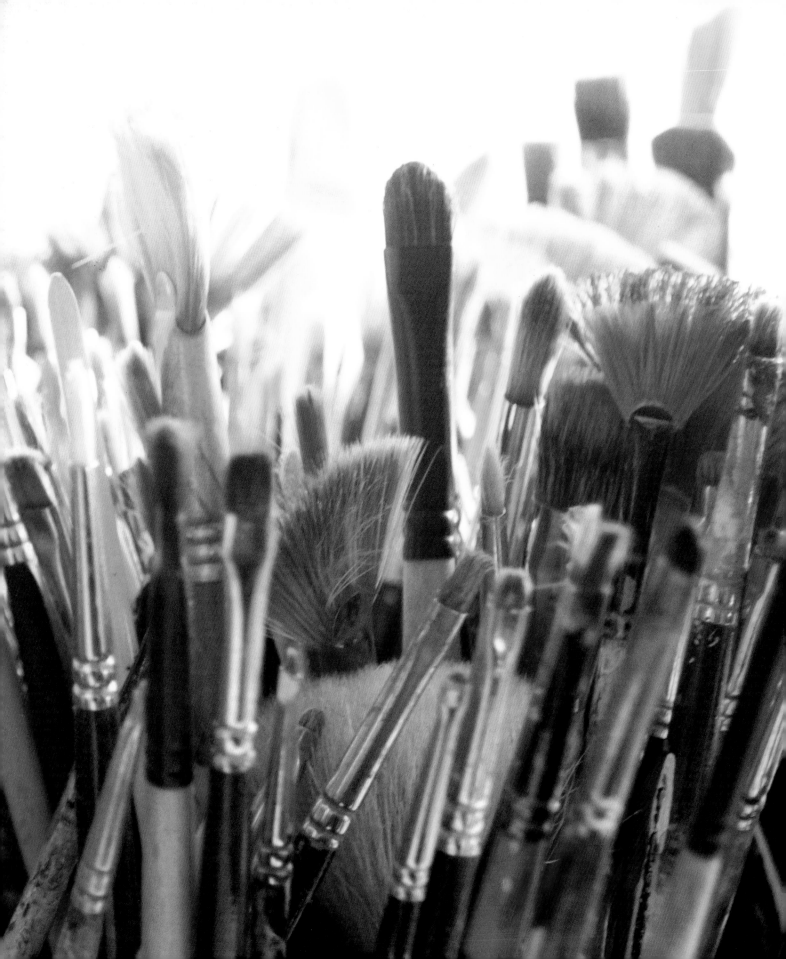

02 PALETTES, BRUSHES & OTHER PAINTING TOOLS

The tools you choose will not make your talent suddenly spring into being, but the right tools will aid your progress, discovery, and innovation. As you read the discussions of tools and look at the examples of art presented throughout this book, ask yourself if you can imagine producing similar results. Always keep in mind that there are many ways to achieve an effect. For example, if I want to make a painting with an expanse of sky, I could use a fan brush. Or I could use a mop with thin washes. I could use a wedge-like paint-shaping tool, spreading several graduated tones ranging from dark to light blue across the canvas. I might even use a roller to create the gradation I want. All this and I haven't even mentioned the possibility of spraying the paint.

The most essential tool you'll use is the palette on which you'll put out your paints and mix your colors, so let's begin with it.

The rich brown tones of a traditional wooden palette are enticing, but wood is very impractical for the acrylic painter. Because acrylic paint is water-soluble, it will damage the grain of the wood, eventually discoloring those rich tones that attracted you. Many artists also find that mixing paints on a colored surface makes finding the right mixed hue more difficult.

Masterson's Palette Seal is an ideal storage container for a dry palette measuring up to 12 x 16 inches.

I have found that a sheet of strong safety glass like the one shown here makes a very good dry palette. A white or gray plastic palette is also a preferable choice for a dry palette, because as with the glass, you'll be able to see the colors you're mixing better, so you won't have any surprises when you apply them to the painting. Unlike wood, these surfaces are impervious to water and should not stain from any of the colors commonly available.

THE PALETTE: DRY OR WET?

A palette is any surface you use for mixing colors before applying them to a painting. You might not think that the kind of surface you mix your paint on would make much difference in how you execute the painting or even to the final outcome of a work, but it certainly does when you're painting with acrylics. There are two main types of palettes for acrylics, and the difference between them is whether the palette is "dry" or "wet." Painters using some variation of a wet palette have almost always produced acrylic paintings with gradual tonal changes with no difficulty. A dry palette, however, is seldom used when it is important to keep a range of tonal changes available over any length of time, because regular acrylic paint simply dries out too quickly on a dry palette.

THE DRY PALETTE

A dry palette is the kind of artists' palette you're undoubtedly already familiar with: a surface of wood, plastic, or paper, commonly portable enough to hold in one hand. Dry palettes were what painters used even before Flemish artist Jan van Eyck perfected the mixing of oil paints early in the fifteenth century. But a dry palette may not be the best choice when you're working with the fast-drying acrylic paints that were the only acrylics available for the first fifty years of the medium's history. The newer acrylic paints, discussed in chapter 1, that have an extended open time do lend themselves to a dry palette, however.

A dry palette does have one advantage over a wet palette: it allows the painter to maintain what is sometimes called a "sweet spot"—a workable thickness that isn't really possible with a wet palette because of the thinning of the paint that continuously occurs with the latter. I have managed to keep paint workable on a dry palette for more than two weeks by keeping the palette in an airtight box—like Masterson's Palette Seal shown middle, left—between painting sessions and by misting occasionally with water.

ARTFUL TIP Don't Do It Yourself

On YouTube, you'll find a number of videos teaching you how to make your own wet palette using paper towels. Don't do this! If you do, you'll end up with paper fibers in your paint, so spring for one of the commercial wet palettes instead. The small amount of money you'll save with a homemade palette simply isn't worth it.

THE WET PALETTE

A wet palette allows you to return to the same fresh paint day after day. There is no crusty, dried-out skin on the colors, and you can start just where you left off. This isn't only convenient but will also save you a lot of money in the long term, since you won't have to continually replace paint that's become hard and unworkable, as it does if you use a dry palette and conventional acrylic paint.

The design of a wet palette is simple: It consists of a fairly flat, sealable plastic box containing a thin sponge; a sheet of special paper that is exceptionally porous rests atop the sponge. When the sponge is dampened, the porous paper transfers moisture to the paint placed on it, and when the lid is closed the paper (and therefore the paint) remains damp for an extended period of time because of the constant ambient humidity of the environment within the box. The paper is also very tough; even though it stays damp, it doesn't tear easily.

A few art materials manufacturers make wet palettes, but the most commonly available brand—and the brand that I have used for over thirty years—is Masterson. The company makes two kinds of wet palettes: the Masterson Sta-Wet Premier Palette, which costs about twenty dollars, and the slightly more expensive Masterson Super Pro Palette, whose hard white plastic case can also double as a dry palette if you need it. The Super Pro has a slightly smaller work surface (10 x 14¼ inches) than the Premier Palette (11¾ x 16 inches). I should note that the Super Pro lid doesn't close quite as snugly as that of the Premier Palette (or, as a matter of fact, as the lid of the Palette Seal box discussed in the preceding section). Replacement sponges and paper for both palettes are readily available.

To reduce the risk of mold inside the sealed palette, I add a little bit of household ammonia to the water with which I wet the sponge: about two tablespoons to a pint of water. (Ammonia, by the way, is part of the formulation of most

Today, paper palette pads are available from many manufacturers. An advantage is that at the end of a painting session you can simply discard the sheet you've been using. Most paper palettes are white, but I find a gray paper palette more useful, because mixing color on this middle-value surface provides an easier path to accuracy.

ARTFUL TIP A Wet Palette That's Even Wetter

I discovered the Masterson Sta-Wet Palette at about the same time that I first made the mixture of water, flow enhancer, and retarder that I call "Van Patten's Solution" (see page 22)—and it soon dawned on me that I could use a very diluted version of this solution, with just a splash of retarder and enhancer added to the water, as a wetting agent for the palette's sponge. The obvious benefit is that the paint is constantly infused with the agents that improve flow and extend open time. Using Van Patten's Solution in this way, I have been able to keep mixed color workable for about two years, though I don't recommend trying to keep paint that long! One slight disadvantage is that the paint will become a little less viscous.

Masterson makes two somewhat different wet palettes: The Sta-Wet Premier Palette (top) is the basic model, with sponge, paper, and an airtight box. The Super Pro (bottom) is slightly smaller; its lid doubles as a divided palette for watercolors (not really useful for acrylics).

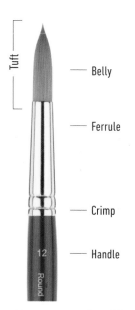

A brush's anatomy consists of the tuft (with a "belly" that holds the paint); a metal sleeve, called the ferrule, that holds the hairs or bristles in place; and a wooden or plastic handle (secured by a crimp in the ferrule).

acrylic paint.) The unpleasant odor of the ammonia will dissipate very quickly, and you may repeat this treatment any time your wet palette starts to smell of mold. This is more than the amount recommended by Masterson, but I have found that less is ineffective in preventing mold and mildew.

BRUSHES

As Van Gogh reportedly said, "Painting is drawing with color." If the beginning painter can think of the brush as a kind of drawing tool, starting to paint may seem easier. When teaching a class of people new to painting, I suggest that each student buy a couple of small brushes (sizes 2 and 4). A small brush with a small charge of paint may be used more or less like a pencil or a piece of charcoal and can provide a nice bridge between drawing and painting.

I suggest you do the same—or, better, buy one of the prepackaged sets of brushes offered by many brush companies. You can start with either a synthetic or a mixed synthetic/natural hair set. You will probably pay about half of what you would if you purchased the brushes separately. I also recommend you buy one painting knife (also called a palette knife) like the one pictured opposite to be used for paint mixing and for keeping the palette orderly.

BRUSHING UP Taking Care of Your Brushes

If you want your brushes to last, you've got to keep them clean. Careful washing should follow the use of any paintbrush. Work dish detergent into the base of the hair near the ferrule. Scrub the brush against the palm of your hand using a circular or back-and-forth motion. You are finished when you don't see any color coming from the brush—just white suds. After the brush is completely clean, and while it is still wet, shape the brush. If the brush fails to take its original shape, fill the brush with soap and water as though you were cleaning it again. This time do not rinse the brush, but shape it into its original shape while it is still soapy and wet.

Somewhat reluctantly, I will also mention a method of removing dried acrylic paint from brushes. The one sure solvent for dried acrylic paint is acetone. This is a flammable, poisonous fluid, which should be used only after the warnings on the container are read and the dangers considered. If you still decide to use it, be sure there is adequate ventilation (outside is best) and there is no chance of any fire. The Silicoil-brand brush cleaning jar (right) has worked for me. I fill it with acetone and use it with great caution. There are other, less dangerous cleaners available, which can be used with the same type of container, though they may be less effective than acetone. Try Bristle Magic or Blick Artist's Acrylic Remover.

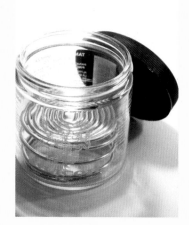

The coil inside this brush-cleaning jar holds the tufts of the brushes above the sediment that gathers below.

As you progress as an acrylic painter, you'll definitely want to acquire more brushes. There are numerous types, with each shape having a different feel and purpose. The sidebar on pages 36-37 covers the basic types that are most useful to the acrylic painter. Another sidebar, on page 40, lists several specialty brushes and describes their uses. Use these as references as you build your own collection of brushes. Brushes are the most basic of tools that an artist has. While it is the imagination and skill of the artist that produce the content of a fine work of art, the tools used to achieve that goal should be chosen with care and treated with the respect that such equipment deserves.

The most important consideration when choosing brushes for acrylic painting may be the kind of hair or bristle from which the tuft is made. There are two broad classifications of brush hair: natural and synthetic. It is generally agreed that natural hairs—most often made from animal pelts—are not the best choice for acrylic painting. That's because all these hairs are porous to some degree, meaning they have a tendency to soak up and hold water. And water will eventually weaken the brush hair, making it break off or fall out of the brush. Over the last few decades, however, brush makers have created synthetic filaments that successfully mimic natural hairs, sometimes even surpassing the resilience of animal hair. (Princeton Art & Brush Co.'s Catalyst line is a good example of such high-quality synthetic brushes.)

Brushes nowadays are often made with a combination of natural and synthetic materials in varying proportions. Because there are so many different kinds of brushes with so many combinations of hair, it is difficult to make specific recommendations. Also, every artist has his or her own individual likes and dislikes. So the best advice I can give is this: If you already have some brushes, begin by using them. After you've finished a few acrylic paintings, you'll begin to see which brushes you prefer to use. Trust yourself. Or begin with just a few brushes of different sizes and shapes from the same line—perhaps in one of those pre-packaged sets mentioned earlier—to find out whether you're comfortable with the feel and the result. If not, try another line. You'll certainly want to visit an art supplies store to look at and feel the brushes. If pressed to make a recommendation, I would say that Princeton Art & Brush Co.'s RealValue Brush Selection Pack "combination set" (see photo, right), which includes both synthetic- and natural-bristle brushes in a range of sizes, has the greatest variety at a very decent price. And remember, there's nothing wrong with asking sales staff for recommendations; many salespeople at art supplies shops are themselves artists or art students and will be happy to help you make decisions.

All that said, it can be useful to know something about the characteristics of various natural and synthetic hairs. Here, based on my own experience using various kinds of brushes with acrylic paints, are some quick notes on their positives and negatives.

Even if you're not using painting knives for impasto, you'll need a painting knife for mixing paints on the palette and for keeping the palette tidy. For those purposes, choose one with a narrow blade.

A prepackaged set of brushes like this one is a good option for the beginning painter.

This part of the book may serve as a quick reference before or while you are embarking on a brush-buying adventure. The many sizes and shapes of brushes can be confusing, but if you make yourself think of function and form as the core principles in choosing brushes, you will be fine.

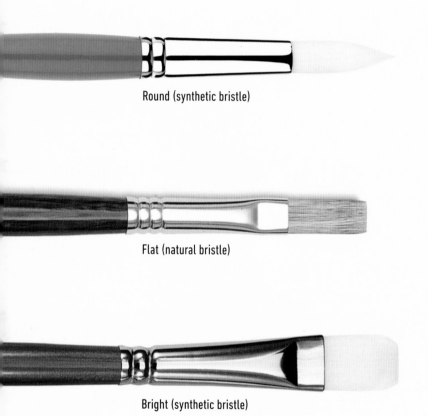

Round (synthetic bristle)

Flat (natural bristle)

Bright (synthetic bristle)

Round

The round is the most versatile and commonly used of all brush shapes. The hair is set in a round ferrule, or collar, and usually comes to a point easily when it is charged—that is, full of paint. Rounds are especially useful for painting edges or any passage requiring some precision.

Flat

The flattened ferrule gives the brush known as the flat its chisel-like shape. Flats typically are very good for applying paint in areas needing either a smooth or impasto surface, but not quite as good when a drier paint charge is needed because the length tends to reduce the control needed in smaller more vigorous scumbling applications. They're useful if you want a stroke to have a squared-off beginning or end.

Bright

The bright is shaped much like the flat, but the bundle of hairs is shorter. Used in many of the same kinds of passages as flats, brights are also very good for creating a scumbled surface. Scumbling means applying a (usually) thin coat of paint with an almost-dry brush in a sort of scrubbing fashion, forcing the hairs into the surface rather than sliding the brush across the passage.

Filbert

The filbert gets its name from the shape of its tuft, which is both flat and rounded, sort of like the shape of a filbert nut (a kind of hazelnut). This unusually shaped brush, whose tuft becomes an oval at the tip, may be used much as a round, flat, or bright, though the oval tip produces a unique stroke.

Some brush companies are now offering a short-haired filbert (also pictured), which I find useful for the way I paint. I often use a lightly charged brush to scumble thinly applied paint with a soft edge definition. The short-haired filbert is one of the few brushes that meet this need.

Egbert

The Egbert is basically an extra-long filbert. Its shape and length make the egbert a great paint carrier (better than a filbert), and hog bristle egberts have a wonderful spring even when fully charged, which comes in handy when you're working with very thin paint. An egbert will retain its shape well if you are careful not to leave it bent while resting in water or, even worse, to let it dry in a bent state.

Fan

The wide, thin fan brush was designed primarily for blending, though I have also used fan brushes for glazing and even varnishing. Because a fan brush holds a very limited charge of paint, its hairs get involved with neighboring areas of paint as it glides across the canvas, making it the ideal tool for blending one color into another.

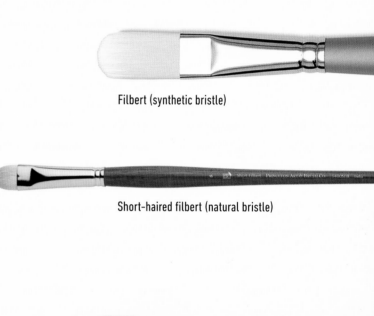

Filbert (synthetic bristle)

Short-haired filbert (natural bristle)

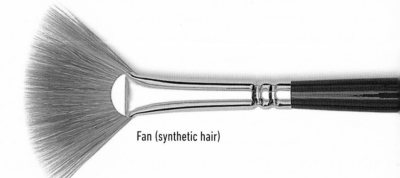

Egbert (natural hog bristle)

Fan (synthetic hair)

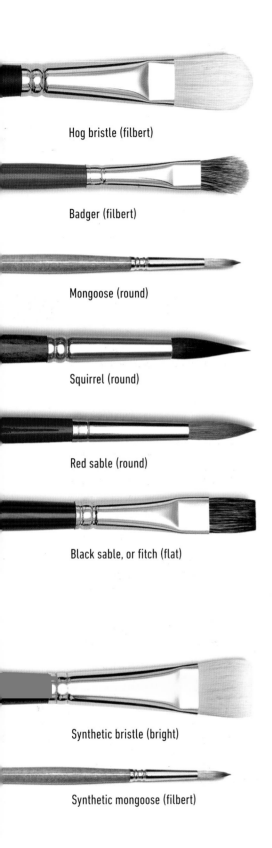

Hog bristle (filbert)

Badger (filbert)

Mongoose (round)

Squirrel (round)

Red sable (round)

Black sable, or fitch (flat)

Synthetic bristle (bright)

Synthetic mongoose (filbert)

NATURAL BRUSH HAIRS

Hog bristle is the toughest of all the natural hairs. Artists generally use hog-bristle brushes when scumbling or when any other vigorous application of paint is needed. Brushes made from Chungking hog hair, a Chinese product, have been favored for many years because of this hair's durability.

Badger is a soft yet springy hair. I often use badger-hair brushes, though I do not recommend them to other painters because this natural hair is so soft that it can wear down in just a week of use. Oddly, it is this fragility that makes badger a good choice for me, because the brush wears down to a blunt, almost filbert-like shape—but much smaller and shorter than any filbert I have been able to find. If you wish to use badger brushes, you can minimize wear by using one of the slower-drying paints, which helps prevent the buildup of dried paint at the ferrule that, over time, can break the hairs.

Mongoose is very similar to badger hair but less springy. I have been disappointed with these brushes, because I tend to use a scrubbing or scumbling application of paint.

Squirrel has always been a poor choice for me because of the harsh treatment I tend to give brushes. Under that treatment, squirrel brushes suffer excessive hair loss, and I've found they have a rather flabby feel when used with paint of almost any viscosity; however, squirrel brushes are good when using very highly thinned paint for washes or any time you need exceptional fluid-holding properties—so I do recommend squirrel if you are primarily painting in a thin, radiantly transparent watercolor style.

BRUSHING UP Handles, Long and Short

Brush handles come in different lengths, dictated by custom, the medium used, and the scale of the work. Traditionally, long-handled brushes have been used for painting with oils and acrylics on canvas—a convention that probably came into being because an artist working at an easel on a large-scale painting often needs to step back from the work to see what's happening on the canvas. Also, long-handled brushes enable a more "painterly" technique, because you can hold the brush near the handle's end—a very different grip than you use when working with a pencil, for example. For beginners, I recommend longer-handled brushes because they allow more flexibility in style (painterly or looser brushwork) and because the greater distance from both painting and palette helps keep things neat.

Red sable is commonly thought of as the gold standard for delicate and precise paint handling. Red sable brushes are most suitable for slow-drying paint that's used quite thinly. These brushes require careful handling and are definitely not good for scumbling or any really vigorous brushwork.

Black sable is also known by another name: fitch. (Just one more slightly confusing thing in the world of paintbrushes.) It is much like red sable, but the hair shafts are slightly thicker, giving black sable/fitch considerably more spring. The exceptional smoothness of its stroke makes it the brush of choice among portrait artists and many other realists. You'll find that black sable/fitch brushes may be even a little more expensive than red sable.

SYNTHETIC BRUSH HAIRS

Acrylic painters most often use brushes with synthetic hair. Because of major innovations and improvements by brush manufacturers, the selection of synthetic brushes (and brushes that combine synthetic and natural fibers) that are specifically designed for acrylic and other non-oil-based paints is now extremely broad. Among the synthetic brushes that mimic natural-fiber brushes are synthetic bristle, synthetic mongoose, synthetic squirrel, and synthetic sable (see photos opposite, bottom and top, right). These synthetic-hair brushes have the same attributes as their natural-hair counterparts—except that, in some cases, they're better. For example, the Princeton Art & Brush Co. produces a unique synthetic mongoose that performs like its more costly natural twin but lasts much longer. In fact, most synthetic facsimiles of natural hairs have longer life-expectancies.

And then there are the synthetic fibers that don't mimic natural hairs—including Taklon, a polyester fiber (originally developed by DuPont) that permits an exceptionally smooth, velvety application of paint on many kinds of surfaces, both smooth and coarse. Taklon brushes retain their shape very well and, like other synthetics, do not soak up water to become saturated and thereby compromised.

I personally have a brand-new favorite among synthetic-hair brushes: the line of Catalyst Polytip Bristle brushes created by the Princeton Art & Brush Co. These brushes have a completely different feel from any others. Their somewhat rigid though springy and responsive filaments taper toward the tip and then end in a multipart tip that imitates the "split ends" of natural hairs. This "polytip" enables the brushes to discharge paint in a uniquely even way. The most important function of a brush is to deliver its charge of fluid to the painting, and these brushes give the artist an unprecedented degree of control. (However, I am still looking for the "perfect" brush!)

Synthetic squirrel (bright)

Synthetic sable (round)

Several brush manufacturers offer Taklon brushes in both white and golden varieties.

The Catalyst brushes made by the Princeton Art & Brush Co. are a great advance in synthetic-hair brush technology.

This promotional shot shows one of the Catalyst brushes in use.

Specialty brushes, like the dagger and the rigger, are not usually considered essential for "fine art." Instead, they are typically used by sign painters or those who add racing stripes to cars. Therefore these are truly specialty brushes. Though not known for their fine art-associated tasks, these line-making brushes, along with their close relative the angle brush, may be used by artists working with abstract painting to great advantage. Since painting has no set boundaries, having been freed by the modern thinking that emerged in the twentieth century, the craft of the sign painter may very well be combined with that of the fine artist.

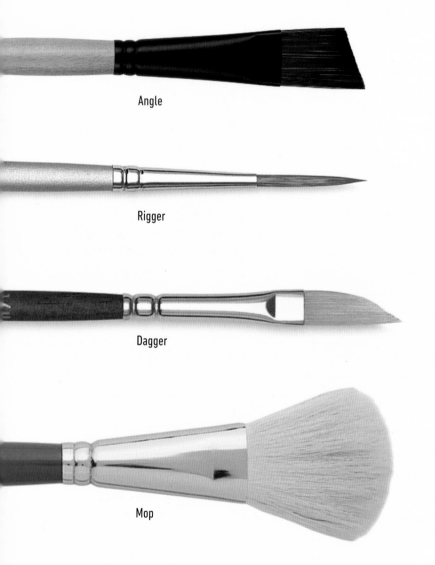

Angle

Rigger

Dagger

Mop

Angle

The hair of an angle brush is cut at an angle for making precise curves and lines. Angle brushes may be either flats or brights, like the Catalyst synthetic Polytip Bristle brush pictured here.

Rigger

The exceptionally long-haired brush called the rigger is primarily used for painting long thin lines. A natural-hair rigger is shown.

Dagger

Though it is designed for painting stripes, the dagger may also be used for curves and fine-edged detail work. A synthetic-blend dagger is shown.

Mop

The mop is usually used with thin, watery applications of paint and seldom if ever with thicker mixtures of unthinned acrylic paint. One possible point of confusion: You'll sometimes see a similarly shaped brush, called the oval wash brush, also referred to as a mop. But don't trouble yourself over this. When searching for a brush that will hold a lot of watery paint, just look for one with a large, somewhat foppish tuft, and don't worry about what it's called. The mop shown is made of synthetic (light gold Taklon) bristle.

OTHER STUDIO SUPPLIES

Beyond a palette and brushes and perhaps some other painting tools, there are a number of other items that you, as a beginning acrylic painter, must have, as well as some you may want to have. Foremost among the must-haves is the lowly bucket or pail. When I teach, I find that students often forget to bring a bucket to the first class—but a bucket is absolutely essential, since you'll use water from the bucket to wet your brushes and to rinse them between uses. I always think that the larger the bucket, the better: a larger volume of water means that the water won't become unusably dirty so quickly. When it comes to refreshing the water in my bucket, I'm a procrastinator, so a big bucket is a hedge against dirty water affecting my work. A bucket, by the way, is also handy for transporting art supplies and for storing materials when you are not busy making art.

A bucket to hold the water you'll use while painting is an essential tool; it can double as a storage/carrying container for supplies.

Before the advent of the scalable wet palette, airtight jars provided the only means for acrylic painters to mix paints and have those colors remain fresh and usable for subsequent painting sessions. Although they aren't quite so necessary as they used to be, jars with screw-top lids are still useful, especially when you're mixing a relatively large quantity of a color. Inexpensive plastic jars are stocked by many supermarkets and drugstores—and, of course, sold by art supplies shops. Although your project will determine how many of these containers you need and what size they should be, I usually recommend that beginners purchase a package of six small jars. And I also recommend getting several squeeze bottles of different sizes, as well, for mixing and thinning fluid paint and for storing mediums and other additives. And don't forget about all those containers you usually put in the recycling: wash out those mayo and peanut butter jars, and use them in the studio instead of throwing them away.

Squeeze bottles like these are handy for keeping quantities of mixed colors fresh, among other uses.

Paint loses moisture on both the palette and the canvas. Using a fine misting spray refreshes the moisture on the painting's surface, giving you more time to move the paint around even when you're working with ordinary, fast-drying acrylics. And using a mister on a dry or wet palette keeps the paint from forming a rubbery skin. Spray devices come in two basic types: trigger-types and fine atomizer-type misters. The trigger type (like the largest of the sprayers shown in the photo to the right) is great for spraying a large volume of water quickly. But it has been my experience that a trigger-type sprayer can throw out some big blobs of water along with the fine spray, so I usually reserve the trigger sprayer for misting my palette or for misting the painting's surface when I am working a large blended area where the texture of the spray is not very important. Fine atomizer-type misters—like the smaller sprayers in the photo—are much better for dampening fine blended areas where the work demands detailed precision.

Misters and trigger-type sprayers are useful for moistening paint on the palette and on the canvas.

Every acrylic painter's tool kit should include an X-Acto knife.

For cleaning up, keep damp wipes, paper towels, and rubbing alcohol on hand—and don't forget to wear an apron to keep paint off your clothes.

Finally, I don't want to leave the humble X-Acto knife off this list of should-have items. I constantly find the X-Acto knife (with a no. 11 blade) useful for trimming stray fiber or extra cloth off a freshly stretched canvas or even scraping a clump of paint off the surface of a painting when it's dry and too stubborn to yield to any other method.

KEEPING CLEAN AND CLEANING UP

Acrylic paint sticks to cloth very well, making it hard to remove. So you'll be wise to cover your clothes with an apron or old shirt while painting. Keeping a roll of paper towels at hand is also a good idea; choose higher-end paper towels, like Bounty, because you can scrub with them and even rinse them out and reuse them without the towels disintegrating. In an emergency, you can use water from your bucket and paper towels to get wet or not-quite-dry paint off your hands until you can get to a sink and do a real job with soap. If you wish, you can use cloth rags, but be careful to avoid rags that may leave threads or bits of fabric on your brush or your work.

Rubbing alcohol is good for removing dried paint from clothing or anything else. The alcohol compromises the paint's bond to a surface, making it possible to lift the paint off. I have gotten paint on my clothes many times, and I usually use rubbing alcohol followed as soon as practical with one of the prewash stain-removing products available in your supermarket's detergent aisle. (Even if the garment is wool, the application of alcohol is still a good idea.) Dry cleaning will usually get acrylic paint out of clothes, but note: It is usually easier to get the dried paint out if you haven't introduced water while the paint is wet. Water will only thin the paint, causing a wider and more efficient saturation of the fiber with paint. If you work at home and notice still-wet paint on your clothes, you can usually remove it with laundry soap and water. Liquid laundry detergent will mix with the paint, throwing all of the bonding properties of acrylic resin out of play and making water a vehicle for carrying the paint away (scrape the excess off the clothing first).

ARTFUL TIP Painting Knives: An Inexpensive Alternative

For many years, painters have used painting knives, also called palette knives, to manipulate paint on canvas and other surfaces. Knives, like brushes, come in many different sizes and shapes designed for different uses. For the beginner, I recommend just the single painting knife pictured on page 35, to be used primarily for paint mixing and housekeeping on the palette. But if you want to play around with painting knives without spending a lot of money, pick up an inexpensive set of plastic knives like those shown on the right.

In the last few years, a brand-new category of painting tool has come onto the market: the color shaper. The color shapers in the Princeton Art & Brush Co.'s Catalyst line (which also includes brushes) can be found in many better art supplies stores. Some of these tools, made of a rubber-like material with moderately flexible tips, resemble brushes, but they're really unlike anything else. Because of their springy quality, they are surprisingly friendly to someone who has used brushes. Though they cannot be charged with paint they make great rearrangers of workable paint that is already on the canvas. These tools are most useful for painters working with heavier paint and using gels and pastes. If an in-progress painting has several layers of different-colored paint, you can scrape through to reveal one or more of these layers, or you can scrape right down to the base layer. Or you can use one of the wedges to slather layers of impasto color on your painting, allowing only bits of the lower strata of pigment to peek through. It's good to be aware of these tools as your experience grows and you want to try new modes of expression.

Metal painting knives can be expensive, but sets of plastic knives provide a good alternative for the beginning painter who'd like to try working in impasto.

The Princeton Art & Brush Co.'s innovative Catalyst line includes paint shapers (left) and wedges (right).

03 SURFACES FOR PAINTING

Historically, painting has mostly been done on wood panels, on stretched canvases, and, at times, on pigmented wet plaster that becomes part of the wall to which it is applied (the technique known as fresco). Acrylics permit artists to break with tradition, however, since with the exception of glass and glass-like surfaces, you can paint on almost anything with acrylic paint, making the choice of surface both easy and difficult.

Whatever you choose to paint on, the term for that surface is the ground. I've already mentioned, in chapter 1, that the word *ground* as used by artists has two meanings: it can refer to the object on which you paint (e.g., a panel or canvas) or to a substance (e.g., pumice ground) applied to that object's surface to prepare it to receive the paint. In this chapter, I'll introduce you to a few different grounds of the first type, including canvas, wood and metal panels, and paper. And I'll also discuss the most widely used ground of the second type: the primer known as gesso.

Opposite: Juan Escauriaza, *On the Ramp* (detail), 2012, acrylic on linen, 51 X 30 inches (130 X 75 cm). Courtesy of the artist.

Prestretched primed canvases are available in many shapes and sizes.

You'll need a staple gun to attach the canvas to the stretcher bars. The Arrow brand TruTac staple gun pictured here is inexpensive and is easier on the hand than any staple gun I have ever used.

PRESTRETCHED CANVASES

A stretched canvas is the surface most often used for making a painting. It's hardly the only kind of surface that can be used, but since it's so familiar, it's where I'll start. If you're a beginner, I suggest buying prestretched cotton canvases, which come in both medium and medium-coarse weaves. For now, choose the medium weave.

I also make two other recommendations about the canvas that will become your first acrylic painting: First, make sure that the prestretched canvas you buy has been primed with an acrylic primer or a "universal primer." Some prestretched canvases are oil primed—ideal for oil paint but not good for acrylics, because acrylic paint will eventually peel or flake off an oil-primed canvas. Second, choose a small canvas for your first work—any size up to 18 x 24 inches. It's common wisdom among people who teach painting that students should "work big" to free themselves of inhibition and fear of painting, but I don't buy it. Big canvases can be daunting, and working small can give you the satisfaction of working through an idea or even completing a painting in one session—a great morale booster for the beginner. Though prestretched canvases typically come in various grades, that consideration isn't so important for the beginner, so choose whichever grade you can afford.

ARTFUL TIP Beware of Canvas Board

Canvas board, which is commonly available and comes in many sizes, might seem the logical choice for most beginners: it's lightweight, it's inexpensive, and it takes up little space. But I discourage my students from using canvas board for one important reason: the board often warps as the work dries. This makes for problems when framing or otherwise preparing the painting for presentation. To correct the warping, you'll have to glue the canvas board to a more rigid backing or "cradle" it on stretcher bars—which means you'll end up with just the sort of bulky object you were trying to avoid by using canvas board. In either case, you'll be wasting time—time that would better be spent painting!—on a difficult and unnecessary task.

I should mention, though, that there is one line of products that doesn't have this warping problem: the Paint Boards manufactured by the Fredrix company, a major canvas maker. These professional grade panels are by far the best substitutes for ordinary canvas boards. Framing may still present some difficulties—though no more than with any thin panel.

STRETCHING YOUR OWN CANVAS

Though I recommend that beginning artists use prestretched canvases, I do want to talk about stretching your own canvases. Maybe this is a vestige of my early training: when I was in art school, we students had to be able to stretch linen tightly over a wooden frame, securing it with copper tacks and then priming the surface with rabbit-skin glue before we were allowed to even think about painting. Stretching a canvas yourself, however, is no longer a necessary part of being a painter at any level. I have friends who paint on canvas stapled to plywood, and when they finish a painting they have someone else stretch and frame it. But knowing about the stretching process may provide you with a wider range of creative possibilities—for example, doing unusually proportioned or sized work or elliptical, round, or other shaped canvas paintings. Also, though it sounds sentimental, I do think that the process of stretching a canvas may bring you closer to the reality that a painting is a physical, made object—a sensual thing. To stretch a canvas, you'll need a staple gun like that shown in the photo left. You may also want to use canvas pliers to pull the canvas taut, though I usually find that pulling the fabric by hand provides a good-enough result. The sidebar on pages 48–49 details the basic steps.

If you're going to stretch a canvas, the first thing you'll have to do is choose the fabric. The two swatches of fabric shown left represent two common options: unprimed medium-weight cotton and unprimed portrait linen. The medium-weight cotton, which is what I recommend for beginners, is moderate in price, stretches easily, and provides a surface that's not too rough. This is the canvas used in the stretching illustrations pictured on pages 48–49. The finer linen weave—called portrait linen because its smooth-textured surface is favored by realist portrait painters whose work is often very detailed—is somewhat pricey by comparison. The linen is great for the work I do, because the scale is rather large and my manner of working can place enough strain on the stretched surface that a cotton canvas can become "flabby," sagging and pulling at the corners. I have found that a tight, fine-textured material resists this kind of buckling.

Cotton and linen aren't the only fabrics available, however. Artists' canvas is now being made from a variety of materials, including polyesters, blends, and the rough fiber called jute. Canvas also comes in a number of different weights, weaves, and per-square-inch thread counts—all factors that may influence your decision-making as you progress as a painter.

Unprimed medium-weight cotton canvas, top, is a good choice for the first canvases you stretch yourself. Unprimed portrait linen, bottom, is a standard choice for work requiring a smoother surface.

When stretching your first canvas, work small. You'll need four wooden stretcher bars (available in a variety of sizes from any art supplies vendor) and, of course, the fabric. Because I usually paint on linen rather than cotton canvas, that's what I used in creating these instructions. You'll also need a rubber mallet, straightedge, pencil, X-Acto knife or scissors, and staple gun.

1) Assemble the stretcher, gently tapping the ends of the bars together with a rubber mallet (and making sure they're square), and lay the stretcher on the cloth. Here, I created a square format with four 32-inch stretcher bars, but you may prefer a rectangular format.

2) Now, mark the trim lines on the cloth using a straightedge and pencil. Because of the dark color of the linen, I used a white pencil, but any color of pencil will do. The trim size should give you just enough cloth to cover the backs of the

stretcher bars—probably between 2½ and 3 inches beyond the stretcher on each side. To get a closer estimate of just how much cloth you need, pull the cloth loosely around the stretcher; if it covers enough of the back of each stretcher bar that you'll be able to staple it comfortably, that will be plenty.

3) Trim the cloth. I generally use an X-Acto knife because I have difficulty getting a straight cut with scissors, but feel free to use scissors if they're more comfortable for you.

4) Begin the stretching process by folding the cloth over one bar and inserting a single staple in the middle of the back side of that bar. Then pull the cloth tight and put a staple in the opposite bar, directly across from the first one. You have now established the first bit of tension in the stretching process.

5) Now, do the same thing on the other two bars of the stretcher.

 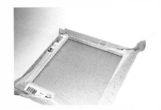

6) Continue by stapling all around the stretcher, pulling the canvas taut as you do so. Once you have three sides fully stapled, you can begin doing the corners at one end of the stretcher, as shown in the next-to-last photo. The process of doing a corner is the same as making a "hospital corner" when making a bed: fold the cloth over the stretcher corner at a 45-degree angle, and staple securely in place.

7) Once you've done all four corners, the back of your stretched canvas (or linen) will look something like the one above You'll note that the job I did is not beautiful: The staples are unevenly spaced, and the amount of cloth overlap differs on each side. But it's a good, tight-enough stretch. I'm much more interested in getting this done quickly and serviceably, because I would rather spend time painting the canvas than stretching it.

8) You'll notice that a crease remains in the cloth, indicating that the stretch is not absolutely tight. That's okay, because the crease will disappear when the canvas is primed with gesso. (See the sidebar on pages 52–53.) In fact, it's probably better if the canvas is not stretched as tight as a drum; since priming tightens a canvas further, coating an already-drum-tight canvas with gesso can sometimes cause the stretcher to warp.

Golden and other acrylic paint companies make a variety of gessoes, including traditional white gesso, as well as gray, clear, and black.

Rather than using gesso, you might prime a canvas with a binding fluid like Golden's GAC 200.

GESSO

Unless you're intending to work directly on unprimed canvas (see the sidebar "Raw Canvas and 'Sculptural' Paintings," on page 51), you'll need to prepare the ground of your newly stretched canvas before beginning to paint. Preparing the ground entails modifying the surface with a substance that both acts as a barrier between the raw canvas and the paint and helps the paint bind to the foundation of the painting's surface, or ground. For centuries, artists have used a white priming material called gesso (pronounced JESS-oh), which in its traditional form is made from rabbit-skin glue, chalk, and white pigment. Today, acrylic painters use commercially made gessoes that contain an acrylic binder rather than the ancient glue-based binder. For instructions on gessoing a canvas, see the sidebar on pages 52–53.

Gesso (whether the traditional kind or the newer, acrylic-based kind) is usually bright white, but the past few years have seen the development of black gesso and colored gessoes. (Liquitex makes a gray gesso that I'm rather fond of.) There's also a gesso that is clear when dry. This transparent gesso allows sanding just like white gesso, but it gives artists the option of working on a primed canvas that retains the natural tone of unprimed cotton duck or linen— an interesting alternative to the intimidating glare of a blank white-gessoed canvas. (I'll discuss the possibility of working on a nonwhite surface when I talk about getting the paint onto the canvas, in chapter 7.)

Gesso comes in varying grades and weights, or degrees of thickness. The thickest is customarily spread on a canvas with a spatula-like tool as carefully and evenly as possible, then sanded smooth when dry; more gesso is then applied until the desired degree of smoothness is achieved. More commonly, however, a more liquid gesso is brushed on a canvas or other surface in a fluid form thin enough that the gesso will self-level. Bear in mind that perfecting a gessoed ground depends on the surface being absolutely free of any grease or oil. Acrylics will not form a permanent bond with a surface that has even a trace of oil.

Besides gesso, there are other options for priming a canvas or other surface. For example, Golden makes a non-color-bearing acrylic fluid, called GAC 200, that when applied as a priming coat ensures an ultrastrong bond between paint and nearly any kind of surface. Like the clear gesso mentioned previously, GAC 200 is transparent, although it is a bit too slick to sand successfully.

ARTFUL TIP Raw Canvas and "Sculptural" Paintings or Shaped Canvases

Acrylic paint has made possible what was not formerly possible. Historically, raw, unprimed canvas was never used for painting because of the damage oil-based paint does to cotton fibers. Beginning in the 1950s, however, a number of painters—including Morris Louis and, later, Ronnie Landfield—began using acrylic paints to create works by staining unprimed canvas rather than brushing the color on. These works celebrate color, liberating painters from the necessity of using brushes.

During the 1960s, Frank Stella began staining raw canvas with acrylics but then went even further, moving outside the two-dimensional, rectilinear format that paintings had always had. By giving new shapes to his canvases, Stella nudged painting into territory once owned by sculptors alone. On occasion, I myself have experimented with "sculptural" paintings, or shaped canvasses.

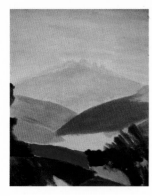

Top Left: Ronnie Landfield is a painter who has used acrylics on unprimed canvas, for example in this painting, *East of the Allegheny*.

Ronnie Landfield, *East of the Allegheny*, 2009, acrylic on canvas, 150 x 108 inches (381 x 274 cm). Courtesy of the artist.

Top Right: American abstract painter Morris Louis was one of the first artists to use acrylic paints to stain unprimed canvas.

Morris Louis, *Intrigue*, 1954, acrylic on canvas, approx. 78 x 117 inches (198 x 297 cm). Princeton University Art Museum, Princeton, NJ.

Bottom Left: My painting *Back Beside the Hill* is a two-canvas painting, with the green shape on the right being a separate canvas fitted into the inverted L-shaped canvas on the left.

James Van Patten, *Back Beside the Hill*, 1969, acrylic on canvas, 48 x 54 inches (122 x 137 cm).

Bottom Right: Using acrylics, Frank Stella changed the very shape of paintings, as in *Harran II*.

Frank Stella, *Harran II*, 1967, polymer and fluorescent polymer paint on canvas, 120 x 240 inches (305 x 609.5 cm). The Solomon R. Guggenheim Foundation, New York.

ARTFUL PRACTICE Gessoing a Canvas

In these instructions, I'm using clear gesso to prime the linen canvas I stretched in the sidebar on pages 48–49. One of the things I like about this gesso is that it gives a surface much the same feel as a surface primed with traditional rabbit-skin glue, while also letting the fabric show through. This allows the color of the fabric to be part of the color palette of the painter.

1) To begin, pour a puddle of clear gesso in the middle of the stretched canvas.

2) Brush the gesso all over the surface as if you were frosting a cake, just to get the canvas completely covered. I use a fan brush for gessoing, though you might choose a high-quality housepaint brush or one of the brushes made specifically for gessoing and available from art supplies stores.

3) Now, rebrush the surface so that all strokes are going in the same direction.

4) Rotate the canvas 90 degrees and again rebrush, with all the strokes running perpendicular to the earlier strokes. The goal is to eliminate as much evidence of brushstrokes as possible.

5) Allow the surface to become dry to the touch (about two hours) before proceeding.

6) Now, sand the canvas, rubbing the sandpaper in a circular motion across the surface. I began sanding with a medium-coarse sandpaper because I wanted to "knock down" the rough texture of the linen, but the grade of sandpaper you choose will depend on what kind of surface you want to achieve.

7) Now, repeat the whole process: pouring the gesso onto the canvas, spreading it around, brushing the gesso in perpendicular directions, allowing it to dry, and sanding. You'll notice when spreading the second coat that the gesso doesn't sink in as readily as it did when applied to the raw fabric, so use a paper towel like a squeegee to smooth out the gesso and remove any excess, as I'm doing here.

8) The final image here is what the linen canvas looked like after a second sanding. (I used the same medium-coarse grade of sandpaper on the second coat, but if I wanted a smoother surface I would use a finer grade.) Note that the process doesn't have to stop after just two coats. Depending on the kind of surface you want, you may apply additional coats, re-sanding after each one dries. Because I like to work on a very smooth, board-like surface, I've sometimes applied and sanded as many as seven or eight coats of gesso before beginning to paint.

PANELS

Before stretched canvas became the most common surface for paintings, artists used rigid surfaces because paint was such a fragile material. The paints that predated oil paints consisted of pigment in sticky mediums like raw egg or gummy substances like acacia gum (commonly called gum arabic) or other resins. Pigment was also mixed with milk, with the casein in the milk forming a bonding compound that made the pigment stick to a surface. It was only after flexible oil paint was introduced that canvas became practical as a support for paintings. Acrylic paint is the most flexible of all paints and thus well suited for a flexible surface like canvas. But it also works well when applied to a smooth, rigid surface, so many acrylic painters, especially hyperrealists and portrait painters whose detailed, precise renditions are difficult to achieve on canvas, choose to work on panels instead.

Panels today are often made of birch or basswood. A number of pre-gessoed hardboards are also available. If you choose to use one of the natural-wood panels, you probably will want to gesso the surface before beginning to paint, following the same procedure used when gessoing canvas (see pages 52–53).

Hyperrealist painter Rod Penner often prefers to work on panels rather than canvas.

Rod Penner, *House with Wave Runners*, 2012, acrylic on panel, 10 x 15¼ inches (25.4 x 38.5 cm). Courtesy of the artist.

Metal panels provide an extremely smooth surface and, if desired, can produce a reflective effect shining from below the surface of the paint. Among the most innovative surfaces used for acrylic painting are panels made of aluminum. Tom Martin, whose painting *Summer Sensations* appears above, is one of the most productive of the new wave of young hyperrealist painters now making such a splash in Europe. Martin goes through a rather lengthy priming process before beginning to paint: First, he sands the aluminum panel to give it some "tooth" (or a slightly rough feel). He then washes it and gives it two coats of etch primer (the kind of primer used on cars). And then he follows up with gesso—about fifteen layers! He says that once the final coat of gesso is sanded, "I'm left with a supersmooth, texture-free gessoed panel ready for paint."

The British painter Tom Martin uses airbrushed acrylics on aluminum panels, achieving the astounding hyperrealist effect you can see in this painting.

Tom Martin, *Summer Sensations*, 2010, acrylic on aluminum panel, approx. 41 x 59 inches (104 x 150 cm). Courtesy of the artist.

PAPER AND BOARD GROUNDS

What about working on something other than a canvas or panel? Why not paper? Because acrylic paint is an aqueous (water-based) paint, it's natural to think of watercolor papers, which can provide a good surface for acrylic painting, especially if you're using a technique in which you thin your paints down until they have a watercolor-like, almost transparent quality. Watercolor papers come in many different weights and textures, as well as in blocks. I usually suggest a stiff, heavy-weight watercolor paper—300 lbs., if you can find it. (To be honest, the reason I use this somewhat pricey paper is that I'm too lazy to spend time stretching watercolor paper, which seems like just another impediment to getting down to the process of painting.) Heavy watercolor paper or board—or another option, illustration board—have all become the surfaces of choice for a number of realists and other painters who require a surface that will not compete with the detail of their work.

Synthetic paper offers another alternative. The brand Multimedia Artboard provides a rigid, matte, softly textured surface. The boards, which come in both white and black, may be used as they are or can be scrubbed with a Scotch-Brite scouring pad or fine-grained sandpaper so that the surface gets slightly roughed up. Unwashed, the surface does have a slight water resistance, so if your paint is very thin it might bead up, as on a waxed surface. But when washed, the surface is perfect for most watercolor techniques. Acrylic paint bonds well with these boards' surface, but if you want an even tighter bond, you may apply a bonding fluid like Golden GAC 200, mentioned on page 50, or Atelier Binder Medium. This ground cannot become saturated with water and thus will not warp even though it is quite thin. If you want a more paper-like surface, you can use an absorbent coating such as Golden's Absorbent Ground or Fiber Paste, either of which can create a near-perfect surface for smaller-scale work. The white Multimedia Artboards are an exceptionally bright white, and both white and black are tough enough to permit you to scratch through paint to ground, as I did in the painting shown opposite. The only serious drawback is the board's brittleness; it can be broken like any thin sheet of plastic.

Opposite: The striations running diagonally across the water in my painting *Study in Orange and Yellow and Blue* are scratches made with an X-Acto knife.

James Van Patten, *Study in Orange and Yellow and Blue,* 2009, watercolor and acrylic on synthetic paper, 13 x 10 inches (33 x 25.4 cm). Private collection, England.

04 VISUAL EXPERIENCE

So far, I've dealt only with the physical materials required to make an acrylic painting. But, of course, there's something else that's essential to making any painting: the painter. To become a painter, you have to make use of your hands, your mind, and your eyes—learning to see in a new way. For painters, this sense of seeing the world anew never really goes away, and the process of embarking on a painting, even for a more experienced painter, is full of unexpected events.

The English landscape painter John Constable (1776-1837) had some interesting things to say about the process of seeing. To his biographer, Charles Leslie, Constable remarked, "When I sit down to make a sketch from nature the first thing I try to do is forget that I have ever seen a picture." And he told his friend the poet William Wordsworth, "I never saw an ugly thing in my life: for let the form of an object be what it may—light, shade, and perspective will always make it beautiful." Both quotes are relevant to what I'll discuss in this chapter: the process of learning to see anew, and the various elements that make up visual experience.

Imagine for a moment that you are looking around for something to sketch—trying to see as if you've never seen a picture before—and have no idea of what might make a good subject for a painting. If you were outside in, say, Wichita Falls, Texas, on a partly cloudy day just after a rainstorm, seeing only a highway, a puddle, some signs and telephone poles, and a few unprepossessing buildings, would you even make note of the scene, let alone think of making a painting of it, as Rod Penner did? (See the image opposite.)

Opposite: The subject for a painting might be found anywhere, as demonstrated by the work of hyperrealist painter Rod Penner.

Rod Penner, *Catalina Motel, Wichita Falls, TX* (detail), 2006, acrylic on canvas, 45 x 63 inches (115 x 160 cm). Courtesy of the artist.

REALLY SEEING WHAT YOU'RE LOOKING AT

Talking about seeing is an obvious place to start any conversation about the process of making art. As very young children, we begin using our eyesight as a means to navigate our new world, and we're soon making generalizations about what we see. Then, slowly, we ignore our ability to discriminate between slight differences, choosing to generalize more and more, classifying things as mom, dad, sister, food, house, coat, blanket, and so on. We don't touch hot things, we stay out of traffic, and we don't jump off high places. Gradually, we lose our wonder, amazement, and awe at the world, because it is easier to make these generalizations that are critical to our survival, safety, and comfort. New experiences merely get pigeonholed. The sensual amazement at the world around us is therefore something that most of us have to learn all over again. And those who are able to relearn it may never fully lose the sense of surprise brought by each new day.

To find out what it means to relearn to experience the world, try the following simple experiment. (You'll be using several of your senses, not just sight.) If you happen to have a bunch of grapes in your refrigerator, pluck just one grape from the cluster. First, feel its temperature. Now, roll the grape between your thumb and forefinger. What shape is it, spherical or egg-shaped? How hard can you pinch it without it bursting? (If you squash it, get yourself another grape.) What does the part that had been connected to the stem feel and look like? What color is the grape? What else do you have in the house that's the same or nearly the same color? Now, pop the grape into your mouth and slowly start chewing. Is the force it takes to break the skin the same as it took to break the skin with your fingers? Stop chewing long enough to sense the tartness or sweetness of the grape. Does it taste the same in the front of your mouth as in the back of your mouth? Now, after chewing it completely, swallow it, focusing on its aftertaste. If the grape has a seed, pay attention to what you're doing as you spit it out and discard it.

To see the world with fresh eyes, you'll have to go through a process much like this grape-eating experience. But there's a shortcut you can use to help you develop a new attitude toward the visual world that will almost instantly jog you into a fresh way of seeing. It's a common artist's tool called a viewfinder, and you're going to make a simple version of one. To do this, take a sheet of paper and cut a small rectangular hole in its center, as shown in the photo at left. Now hold it about 9 or 10 inches in front of your eye, looking through the hole at your immediate environment without trying to identify what you see but instead noticing shapes, colors, light, dark, textures, soft and sharp edges—whatever you see as edited by this small window. Don't judge what you see as beautiful or ugly. Just look.

You can begin to relearn to experience the world with a grape plucked from your fridge.

With a simple homemade viewfinder like this one, you can quickly learn to see the world anew.

Now let's apply what you've done with the viewfinder to the making of art. Take another sheet of paper and draw the shape—in a larger size but the same shape—of the little window you cut in the viewfinder paper. Inside that shape, sketch just what you see through the viewfinder. (See my example at right.)

Do this several times, pointing the viewfinder in different directions and sketching only what you see through the hole. Do you find that your senses have been sharpened? When doing this, you will look at objects and places that you may have looked at many times but that are now edited by the boundaries of the viewfinder's edges. This will actually reduce this tiny bit of your visual world into shapes with color and texture, dark and light, and other characteristics that you have unconsciously used to identify those things you already think you know about. You also compose these things as shapes within the edges of your little window to the world and within the edges of the picture plane of your sketch.

Your ultimate goal is to look at everything you see as though you were planning to paint it. The viewfinder can help you train your eye to do that.

Keep in mind that a particular scene might contain sufficient visual material for several paintings. One early fall afternoon some years ago, I came upon just such a spot. As I'm in the habit of doing, I took reference photos, and I have used those photos in creating more than half a dozen paintings so far, some of which are shown here. But, of course, even a reference photo, no matter how wide the angle, represents just a fraction of the environment. The photos of the pond within a wetland I took on that fall day are particular views of a larger area of water, which in turn is a small piece of a township that's part of a county in a state of the United States of America, which is itself a smallish part of planet Earth, which is just a small bit of a solar system in an unimaginably immense universe—probably one of many! My point is that any painting, no mater how grand, is only a fraction of what we see and that all of what we see is only a speck of what can be seen. So look. Pay attention.

THE ELEMENTS OF VISUAL EXPERIENCE

How do we understand what we see? Over the next few pages, I will try to help you start answering that question. There are several elements—at least six, perhaps as many as eight—that help us organize our understanding of the visual world. My way of thinking about these aspects of the seeing process is not absolute. Other artists may use a somewhat different language to describe the process of seeing and of understanding what they see. But most would probably agree that these are the elementary building blocks of visual experience. To begin making art, you'll need to consider each of them.

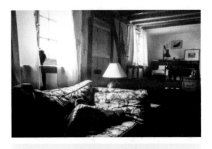

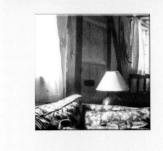

To demonstrate how to use a viewfinder to develop compositions, I first took a photo of the living room in a cottage where I stay in England (top). I cropped the photo as if I were looking through a viewfinder at just a small portion of the room (middle). Then, I made a quick value sketch (a drawing using primarily darks and lights of a viewed—in this case cropped—area, see bottom).

I've found that a single photo can sometimes serve as the basis for several paintings. For example, I used the reference photo above not only for my painting *Over the Edge*, at right, but also some more close-up views.

Above: Digital photo of wetland near Lake Carnegie, Princeton, NJ, in 2005;

Right: James Van Patten, *Over the Edge*, 2007, acrylic on linen, 48 x 64 inches (122 x 162.5 cm). Private collection.

Below: Here's another painting based on the reference photo above.

James Van Patten, *Study in Blue with Red, Green, and Other Colors*, 2008, acrylic on linen, 48 x 48 inches (122 x 122 cm). Courtesy of Plus One Gallery, London.

LIGHT

Light is the starting point of the entire visual world. Of all the elements of visual experience, light is always the most active player. After all, it is light that makes the world visible. But we take light for granted and often don't pay attention to what light is showing us or how differing degrees of light affect what we actually see, as opposed to what we think we see. To help you break from your habitual ways of thinking about light, I suggest that you conduct several very simple experiments:

1. Standing or sitting in a lighted room or out of doors during the daytime, shut your eyes tightly. Then turn your head in a different direction from where you were facing when you shut your eyes. Keep your eyes closed for at least a minute, and then do a kind of "reverse blink"—opening and shutting your eyes very quickly. Your eyes should be open for such a short time that you see very little. Now think about your essential impressions during that brief time your eyes were open:

- Were you aware of dark and light?
- Were you aware of large shapes? Small shapes?
- Were any colors dominant in what you saw? If so, what were they?
- How about texture or line?

2. After the sun has set, go into a room that has a lamp with a dimmer switch. Using the dimmer, turn the lamp on and off, increasing and decreasing the light in the room very gradually. As you do so, notice the level of detail you perceive at each incremental increase and reduction in the level of the light. How does your perception of the room and the objects in it change as the light level grows and diminishes?

On a clear evening, go outside before the sun goes down, and stay there until the sun has set completely. Carefully watch how the definition of the visual world diminishes as the light vanishes. At every moment, note how much you are actually seeing—and how your prior experience dictates your perception of what you see.

Hopefully, these little exercises will make you more aware of how you ordinarily don't think about light. They may enable you to start parsing out perception in a way that can enrich both your artistic memory bank and your visual experience in general.

It has been my observation while watching people learn the skills of painting and drawing that the hardest part is getting the hand and eye to cooperate with each other. It is usually not a problem with the artist's hand or eye but between the eye and the brain. These exercises with light provide several situations in which the act of looking and seeing is not tied to identifying and generalization. When you look at an object in very dim light it can be difficult to immediately

Then I went in even closer, for a series of 8-x-8-inch paintings based on tiny, fragmentary details of the original reference shot. At the top is an installation view; above, a close-up of one of the pieces.

Top: Installation view of "fragment" paintings by James Van Patten.

Bottom: James Van Patten, *Fragment of Study in Blue with Red, Green, and Other Colors*, 2009, acrylic on canvas mounted on board, 8 x 8 inches (20.5 x 20.5 cm). All paintings collection of the artist.

One reason people shy away from making art is their fear of making mistakes or of producing a product that's not as good as they hope for. But let's try to set aside this mistake-making phobia. Let's get rid of the word *mistake* and think in a different way about the kinds of things that happen unexpectedly when you're making a piece of art. One of these things might be called an inadvertency—something that's unplanned and that stands out as a dissonance, attracting more attention to that part of the work than you had intended. You may decide to rework it or even to paint it out. But thinking about it as an inadvertency rather than a mistake changes your attitude and makes the process less frightening, allowing you to see it as an event that enables you to reconsider and reinvent.

The second kind of unexpected thing is what I call a nuance—something that's unplanned but that improves the work. A few years ago, I was working on a painting called *Stowe Slope*, based on a reference photo I had taken (right). My custom when working on a painting this large is to paint the large areas of color before moving to smaller modules for details. As I was mixing the color for the underpainting of one passage, I noticed that the corresponding area in the reference photo seemed to have a slightly blue cast. So I mixed the paint as I saw the color at that moment and continued on with the painting. But weeks later, looking at the completed painting and comparing it to the reference photo, I could no longer find that blue cast in the photograph. I really liked the nuance of the way I had painted it, however. It was yet another instance of something that happens rather often: an unplanned occurrence that makes the work better than it might otherwise have been.

The reference photo above for my painting *Stowe Slope* shows no blue in the area indicated. But when I was painting, I thought I could see a bluish cast there, so it ended up in the finished work, left.

James Van Patten, *Stowe Slope*, 2009, acrylic on linen, 48 x 64 inches (122 x 162.5 cm). Private collection, England.

recognize it as an object you "know" according to a generalized definition. And in the "reverse blink" exercise, you are apt to be aware of gross shape or color but not enough exact detail to say, "That's a _____." In doing these exercises, you're trying to make your brain see differently.

Before going on to the next element, I want to mention one more thing about light: For realist painters, creating the illusion of light shining out from a source is among the most difficult things to do. By contrast, painting colored objects on which light shines hardly presents a problem. How can you depict something that is solely light? I remember a colleague once saying that he wanted to paint light in a way that would hurt your eyes just as the sun does if you look at it directly. Me, too. I haven't quite succeeded, but I like to think I've come close, as in my painting *At the Edge* (below). The trick comes from knowing that white is light; if everything else in a painting—even intense reflected light (except for sunlight)—is at least slightly darker than pure white, then the white of the light source can almost produce the illusion of light shining out from the painting itself.

The bright whites in my painting *At the Edge* create the illusion that light is shining out from the surface of the work.

James Van Patten, *At the Edge,* 1997, acrylic on linen, 48 x 72 inches (122 x 183 cm). Private collection.

Whether pictorial space is flattened, as in my early work *Split Scape* (above), or "deep," as in my *Once upon a Time* (right), a third dimension is always implied.

Above: James Van Patten, *Split Scape,* c. 1970, acrylic on canvas, 36 x 42 inches (91.5 x 106.5 cm). Private collection.

Right: James Van Patten, *Once upon a Time* (originally entitled *Time*), 1989-90, acrylic on linen, 48 x 72 inches (122 x 183 cm). Private collection.

FORM

Form has two aspects: shape and volume. Most paintings are flat; except in those relatively rare instances where the surface has been built up by impasto, creating a relief effect, or where the artist has reshaped the canvas, turning it into an almost sculptural object, the picture exists in two dimensions. Within the painting's flat and rectangular space, shapes are organized and are bound by the painting's edges. These shapes may create the illusion of an external reality or they may be abstract forms, but the issue of volume—of three-dimensional form—always comes into play. This is because most viewers feel an urge to imagine space beyond the flat, two-dimensional, limited space of the picture—as though the picture were a window into a larger reality.

This need for an illusion of space creates a kind of tension in the viewer's mind: the two-dimensional reality of the painting is constantly morphing into a three-dimensional mental experience. When an artist intentionally renders objects in a flat way—with no shading, no gradation, and no highlights but still with the visual suggestion that the shapes represent real objects, people, or places—there's an interruption of that mental flow, and the viewer may find the experience a bit jarring. This is the kind of experimentation that artists began to engage in during the early-twentieth century, causing viewers to do a double take and thereby either enraging them or enriching their visual experience. It is a primary goal of any artist to trap a viewer's gaze long enough to create a memory, and by playing with the visual devices that suggest volume, it is possible to work some of the magic of art. The two paintings reproduced above, which I painted about twenty years apart and which can both be described as landscapes, show this divergence between an ambiguous and perhaps disorienting flat space and a "deep" space that creates the illusion of three dimensions.

VALUE

Traditionally, the creation of the illusion of volume in two-dimensional works of art is accomplished through differing values. As I'm using it here, the term *value* has to do with the relative lightness or darkness of a painted area—white, black, and all the shades of gray in between. The image to the right shows a simple value scale. The addition of white, black, or gray quietly affects color, and painters give colored shapes volume by using lighter (lower value) colors to indicate that light is falling on a shape and darker (higher value) colors to show that a shape is in shadow. This use of value to create a three-dimensional effect isn't limited to realist artists; it's also employed by some abstract painters, as can clearly be seen in the painting by Al Held below.

Here is an example of a simple value scale.

Left: This painting by Al Held depicts nothing real, but instead suggests shapes that the viewer might identify as boxes. More simply, it also shows thick vertical and horizontal lines. At the very least, it is a study in black and white (the two extreme ends of the value scale above). It is a painting stripped to its minimal components.

Al Held, *B/WX,* 1968, acrylic on canvas, 114 x 114" (289.56 x 289.56 cm). Gift of Seymour H. Knox, Jr., 1969. Albright-Knox Art Gallery, Buffalo, NY.

Above: The suspended droplets of water that cause a rainbow act like a prism, breaking white light into its constituent hues.

COLOR

Color is so important to the painter that I devote the whole next chapter to it. True, there are a few painters who work solely in black and white and some others whose work is monochromatic, but for most painters, color is the joy of painting. Curiously, some beginning painters are afraid of color, but I know that you can and will lose that fear and really embrace color.

Let's start the discussion of color by noting that white light is where all color starts. White light is needed to see color—especially white light as provided by the sun. The rainbow pictured left shows the refraction of white light into the spectrum. Although the spectrum is continuous, for convenience it can be divided into twelve separate parts, called hues. You'll use the spectrum when mixing colors and organizing them on your palette, and you'll also learn to modify these pure hues by adding white (to produce what are called tints) and black (to create what are called shades). In addition, you will find out how to neutralize a color by mixing it with its opposite. Throughout that upcoming discussion, my aim will be to get you to feel comfortable with color and to help you create color-rich paintings without fear.

TEXTURE

Among the elements of visual experience, texture has a special place, because it is not just visual; it is also, at root, tactile. When thinking of texture, it is easy to think only of roughness and to forget that smoothness is also an aspect of texture. If you wish to sharpen your sensitivity to the subtleties of texture, you might try shutting your eyes and touching anything within reach. You'll quickly find that you experience both these aspects of texture—degrees of roughness and of smoothness.

In painting, texture has a double aspect: the physical texture of the painted surface and the visual texture of the subject in the painting. These two aspects don't have to conform. For example, a very rough-textured object such as a tree trunk can be painted with very smooth paint.

Besides the representation of texture within a painting, the painting itself has a texture of its own—and that texture may be an important, tactile dimension of the artwork, as when an impasto technique is used or when the surface texture is changed by the use of one of the gels or pastes discussed in chapter 1 (see page 27). The images opposite and above show how two different artists work with visual and tactile texture: Davis Cone gives us a world in which we can almost hear and feel the scrunch of snow underfoot; Elizabeth Blau has produced a painting evocative of ice and snow with texture obviously produced in many layers by alternate blots of light and dark paint (possibly not even using brushes).

Texture can be a crucial element in both realist and abstract paintings, as can be seen—and felt!—in these very different works by Davis Cone and Elizabeth Blau.

Opposite: Davis Cone, *Metro,* 1996, acrylic on canvas, 27 x 42 inches (68.5 x 106.5 cm). Courtesy of the artist.

Above: Elizabeth Blau, *Mass Balance,* 2012, acrylic on canvas, 36 x 78 inches (91.5 x 198 cm). Courtesy of the artist.

Artist Mel Prest uses grouped lines to
create an effect of mass in her painting.

Mel Prest, *Melphoto*, 2013, acrylic on panel,
12 x 12 inches (30.5 x 30.5 cm). Courtesy of
the artist.

LINE

Line is an unusual element of visual experience in that it is very rare to see an example of pure line in the real world. Think about it: What you ordinarily think of as lines are actually the edges or contours of shapes. Even shapes that are very narrow are not pure line—they have some slight thickness. However, line is very useful when we need to describe something: How many times in an effort to describe something to someone have you grabbed a pencil and done a quick line drawing of the thing in question? Line drawing is a fast way of making a plan, whether of a building or a still life. And when beginning a painting, a line drawing is an easy way to break up that blank rectangle or square in front of you and to begin figuring out where the shapes belong.

There are some painters who use a strip of color to move the eye from place to place or to create a tension between shapes or colors. And sometimes lines grouped together can even create the effect of mass, as in the moiré-like patterns of Mel Prest's *Melphoto* opposite.

TIME AND MOTION

Finally, there are two aspects of experience that aren't usually thought of as visual but that do enter into our experience of a work of art and that are, in fact, essential to the understanding of some paintings: time and motion.

You'll remember my saying that every artist hopes to produce a work that will result in a memory on the part of the viewer. That's a tall order, since the actual time you, as a viewer, spend with virtually any artwork is minute in the context of your whole life and your whole memory. To renew that memory might require a physical effort on your part to go back to the place where the artwork is to see it again, or a mental effort to relive your experience of having seen the work. So time and motion are already deeply embedded in our experience of art.

These two paintings by Claude Monet, both painted at almost the same location in a field of humble haystacks, together illustrate the effect of time on our perception. Think of ways you could demonstrate the passage of time in your acrylic paintings.

Below, Left: Claude Monet, *The Haystacks: End of Summer,* 1891, oil on canvas, 23¾ x 39½ inches (60.5 x 100.5 cm). Musée d'Orsay, Paris; photo by Hervé Lewandowski, RMN-Grand Palais/Art Resource, New York.

Below: Claude Monet, *Wheatstacks, Snow Effect, Morning,* 1891, oil on canvas, 25½ x 39¼ inches (64.8 x 99.7 cm). J. Paul Getty Museum, Los Angeles.

Beyond that, however, certain artists have been very conscious of their role as record-keepers who can stop the onward march of time. For instance, in the nineteenth century the impressionist painter Claude Monet did several series of paintings recording views of the same scene at different times of day, under different weather conditions, or at different times of the year, as seen in the views of haystacks in a field near his home in Giverny (page 71). Monet's subject in these paintings is time and its passing every bit as much as it is the landscape. In fact, all the impressionists were focused on the experience of seeing in the moment—the impression of that moment, ergo impressionist.

Then, at the beginning of the twentieth century a group of painters who became known as the cubists tried to depict objects and people from more than one angle at the same time, visually moving the viewer around objects within a painting that is actually flat and static. The painting by Juan Gris opposite provides an example. At about the same time, another group of artists, the futurists, tried to record objects moving past a fixed viewpoint—simultaneously freezing motion at multiple moments and recording time's passing. Giacomo Balla's *Dynamism of a Dog on a Leash* (below) may be the best known of these futurist experiments in recording motion and time within the confines of a static image.

The futurists tried to capture motion in their paintings, as Giacomo Balla does here. There has been little to no serious attempt to render the concept of movement as an element of visual experience for the last hundred years. How might you devise a work that addresses motion in an acrylic painting?

Giacomo Balla, *Dynamism of a Dog on a Leash*, 1912, oil on canvas support, 35⅜ x 43¼ inches (89.85 x 109.85 cm). Albright-Knox Art Gallery, Buffalo, NY.

Cubists like Juan Gris experimented with the idea of communicating movement around objects, seeing them from multiple angles within a single, flat painting.

Juan Gris, *The Violin*, 1913, oil on canvas, 36¼ x 23⅝ inches (92.1 x 60 cm). A. E. Gallatin Collection, Philadelphia Museum of Art; photo by Art Resource, New York

05 COLOR

For acrylic painters (as for all painters), there are two separate but closely related avenues to understanding color. The first is more "intellectual" (for lack of a better word) and the second more practical. The intellectual understanding of color is generally called *color theory*, a body of knowledge that covers what colors are, colors' relationships to one another, and how colors visually interact. The practical understanding comes through actually *mixing colors* on a palette and then using them in a painting. Familiarity with at least some of the basics of color theory will help you as you begin mixing and using your own colors, so that's where I'll start.

The visible spectrum is actually a linear arrangement of hues. At either end, the spectrum continues into invisible wavelengths: ultraviolet and infrared.

The spectrum can, however, be reconceived as a continuous circle in which the violet and red ends are seamlessly connected.

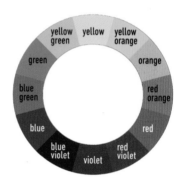

The continuous circle of color can, in turn, be thought of as this simple color wheel, dividing the spectrum into twelve named colors.

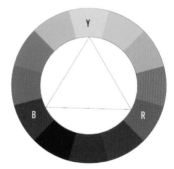

PRIMARY

The angles of this triangle point to the three members of the primary triad: blue, yellow, and red.

COLOR THEORY BASICS

As I touched on in the last chapter, when pure white light is refracted in the water droplets that cause a rainbow (or in a prism), it reveals the range of pure hues known as the visible spectrum. (Note that I use the word *hues* rather than talking about shades of color; the word *shade* has a technical meaning in color theory, which I'll get to on page 90.)

In reality, the visible spectrum is a linear arrangement of hues running from violet to red. But it's possible to join the two ends of this spectrum to create a continuous, closed circle of color, and then to divide the circle into discrete hues—an arrangement known as the color wheel. The color wheel is an ingenious invention that has many uses for the artist.

COLOR SYSTEMS

The color wheel makes it possible to describe harmonies that result from the relationships between specific colors, and it gives you the means for making informed choices about the colors you use in your own work as well as for identifying the ways that other artists have organized color in their paintings. When looking at the color wheel with an eye toward using it in your artistic work, it's best to begin simply—starting with some basic groupings, or "systems," of color within the wheel. You're probably already familiar with the first grouping: that of the three primary colors.

The Primary Triad

The primary triad (*triad* means "group of three") consists of those colors that cannot be made by combining other colors—they're primary in the sense that they can't be broken down into constituent colors. Usually, these colors are thought of as red, yellow, and blue, though some brands of paint identify the primary colors as primary cyan (a form of blue with a slight blue-green cast), primary magenta (a form of red with a slight purple cast), and yellow. You may know these alternate color names from the ink cartridges used in your computer's printer; along with black, these process colors have been used for decades by the printing industry for printing full-color images on white paper.

Paintings that primarily use the three primary colors can be bold—and long on strength of statement—as can be seen in the abstract composition by Moses Hoskins opposite.

The Secondary Triad

The secondary triad consists of the three colors that are produced by mixing two primary colors with each other: red + blue = violet (also called purple); blue + yellow = green; yellow + red = orange. Or to put it the other way around: when purple, green, and orange are "deconstructed," they give us the raw material of all the colors—that is, the primary colors.

The secondary triad can be explained through a simple formula:

1 primary + 1 primary = secondary

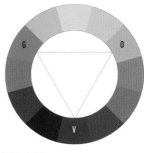

SECONDARY

The angles of this triangle point to the three members of the secondary triad: green, orange, and violet.

The strong visual effect that abstract artist Moses Hoskins achieves in this painting depends, in part, on the prominence of the primary triad among its colors.

Moses Hoskins, *Untitled,* 2013, acrylic and other painting and drawing mediums on canvas, 54 x 48 inches (137 x 122 cm). Courtesy of the artist.

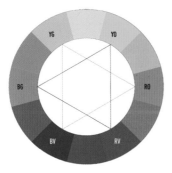

TERTIARY

The angles of the two overlapping triangles point to the members of the two tertiary triads: (1) blue-green, yellow-orange, and red-violet, and (2) yellow-green, red-orange, and blue-violet.

Paintings that predominantly use the secondary colors can resonate emotionally with viewers—an effect I tried to achieve in my painting *On Time*. The secondary triad produces a harmony that is not as intense as that of the primary triad.

James Van Patten, *On Time*, 1988, acrylic on linen, 60 x 60 inches (153 x 153 cm). Private collection, England.

The Tertiary Triads

There are two tertiary triads, totaling six colors, each of which is made by mixing a primary with a secondary color, as described by this simple formula:

$$1 \text{ primary} + 1 \text{ secondary} = \text{tertiary}$$

The names of all six tertiary colors state how each is made: yellow-green, yellow-orange, red-orange, red-violet, blue-violet, and blue-green.

To locate a tertiary triad on the color wheel, start with any of the tertiaries and move around the wheel, counting by fours: for example, if we start out with yellow-green and move clockwise around the wheel, we come first to yellow (1), then to yellow-orange (2), then to orange (3), and then to red-orange (4), which is the next leg of this triad. Then, beginning with red-orange, we count red (1), red-violet (2), violet (3), and blue violet (4), which is the third leg. (Another way of putting this is that there are three colors—one primary, one tertiary, and one secondary—between any two colors in a tertiary triad.) The angles of each of the overlapping triangles in the diagram of the tertiary color wheel (left) point to the three colors composing each triad.

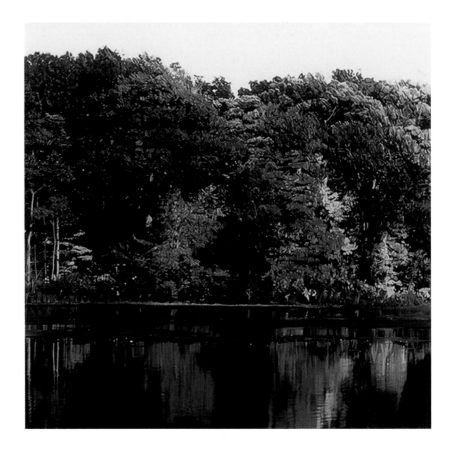

One of the most enjoyable things you can do, once you've learned about color organization, is to go to a museum or gallery and look at paintings to see how these color systems have been used by artists. For instance, the impact of Ronnie Landfield's painting *Angels Vision* (above) depends heavily on his use of one of the tertiary triads. The use of either of the two tertiary triads in a work usually provides the viewer with a sense of harmony not unlike that provided by the secondary triad. The presentation of any three colors (triads) is a means of providing a complete visual color unit, which is in itself an important component of the majority of paintings that have ever been painted.

Ronnie Landfield's *Angels Vision* makes visually compelling use of the tertiary triad that consists of yellow-green, red-orange, and blue-violet.

Ronnie Landfield, *Angels Vision*, 2010, acrylic on canvas, 43 x 53 inches (109 x 134.5 cm). Courtesy of the artist.

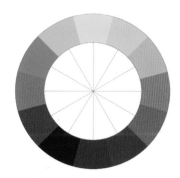

COMPLEMENTARY

Complementary colors are those directly opposite each other on the color wheel.

Right: The complementary paring in Moses Hoskins's Untitled sets up an interplay between the orange in the upper right and the blue in the lower left.

Moses Hoskins, *Untitled*, 2011, painting and drawing mediums on canvas, 30 x 24 inches (76 x 61 cm). Courtesy of the artist.

Opposite: Though representational and much more visually complex than the abstract Hoskins work right, Davis Cone's *Chicago* is also "about" complementary colors.

Davis Cone, *Chicago*, 2011-2012, acrylic on canvas, 43¾ x 28½ inches (111 x 72.5 cm). Courtesy of the artist.

Complementary Colors

Complementary colors are colors that appear directly across from each other on the color wheel: For example, green and red are complementary to each other. In the case of green and red, one color is a primary and the other is a secondary color. One way of looking at this is that a primary color and the secondary color directly opposite it on the color wheel together compose the primary triad, but in only two colors: the primary color red pairs with the secondary color green (blue + yellow) to make a complete primary triad. And this is true if you deconstruct any pair of complementary colors into its components: for example, yellow-green and red-violet are complementary (directly across from each other on the color wheel); yellow-green is a mixture of yellow + green (blue + yellow), and red-violet is a mixture of red + violet

(Continued on page 84)

You should consider other phenomena when thinking about ways to make color work for you. Neither of these quite belongs to the color systems discussed in this chapter; rather, they have to do with the anomalous or surprising effects that color can sometimes produce.

To gain an understanding of the first of these phenomena, look at the figure top right, showing a square of solid red and a square of solid green. Try to look as intently as possible at these two squares for about a minute, and then close your eyes tightly. What do you see?

Now take a blank sheet of white paper and cover up the green square. Again, stare at the visible red square as intently as you can for about a minute, and then transfer your gaze to the sheet of white paper. Does a ghost of the red square's complement—green—suddenly appear?

This phenomenon is called afterimage. To explain afterimage in simple terms, the color-sensitive bits in the retinas of our eyes that are assigned the task of reporting a color—in this case, red—to the brain get tired. When the red sensors are finally relieved of their task, the well-rested bits of the retina that are assigned the opposite color (green—i.e., the most non-red color) are now free to send full-force messages of their assigned color because the normal blocking or shielding function of the worn-out red sensors is temporarily unavailable. The minimalist painter Al Held used the phenomenon of afterimage in a rather amusing way in the acrylic painting *Purple Triangle*. Where is the purple?

The edge anomalies caused when a camera lens catches a burst of intense light are fair game for a painter who uses photos as references. In fact, artistic license may even permit the edge anomaly to be exaggerated. Here, you can see how I dealt with these edge anomalies in my painting *Charlotte Valley Swamp*; shown from opposite top left to right are the reference photo, a close-up view of one section of the painting, and the full painting.

Those of us who work with photographs as references for paintings often find anomalies along the edges of colors because of the way a camera lens deals with bright light. Sometimes there is a touch of red at an edge, sometimes a touch of cyan or a ghost of yellow. You can see this especially clearly in the detail from my painting *Charlotte Valley Swamp* (opposite, top middle).

Really fascinating things can happen at the edges of a color where it meets another color, or where it meets a brilliant white. In the Juan Escauriaza painting opposite, bottom, the edge where the shadow meets the brightly sunlit wall is rendered as a soft, almost orange blur that's neither the color of the shadow nor of the building's bright surface. Try to become conscious of the edges between colors as they appear all around you, to see things you may never have consciously noticed before. Be on the lookout!

Above: Al Held, *Purple Triangle*, 1963, acrylic on canvas 70 x 48 inches (177.8 x 121.9 cm), Private collection.

Al Held's Purple Triangle makes ironic use of the phenomenon of afterimage. If you stare at the yellow triangle long enough and then shut your eyes, the phantom purple triangle will appear.

Opposite:

Top: James Van Patten, *Charlotte Valley Swamp*, 2008, acrylic and watercolor on illustration board, 24 x 34 inches (61 x 86.5 cm). Courtesy of Plus One Gallery, London.

Bottom: A close look at Juan Escauriaza's *A Good Friend* reveals a color anomaly along the edge of the shadow.

Juan Escauriaza, *A Good Friend,* 2012, acrylic on linen, 51 x 24½ inches (129.5 x 62 cm). Courtesy of the artist.

My painting *Thin Red Line* plays with the tension that can exist between complementary colors.

James Van Patten, *Thin Red Line*, 1968, acrylic on linen, 48 x 72 inches (122 x 183 cm). Collection of the artist.

(red + blue); therefore, all the colors of the primary triad are represented in this pairing, as well. By extension, any complementary pairing of colors actually has all the raw material needed to make up the whole spectrum, and a painting in which the artist predominantly uses complementary colors gives the viewer a sense of completeness.

In much abstract painting, the absence of recognizable objects leaves color as a main device to carry the eye through the painting. Thus the Moses Hoskins painting on page 80, which makes such strong use of a complementary pairing, can be said to be "about color." But realist paintings can also be "about color": Take, for example, Davis Cone's extraordinary painting of the Chicago Theatre at night (page 81), which predominantly uses blue-violet and yellow-orange. Although Cone snares the viewer with a powerful illusionistic image while Hoskins provides only color, shape, texture, and line, the eye becomes involved with complementary color in both paintings. (Cone's painting also exhibits the time and motion elements I talked about in chapter 4. Can you see how?)

It's also important to note that there is tension as well as harmony between complementary colors. Back when I was painting abstract images, I would quite frequently include a color that was the exact opposite of the color that was dominant in a painting specifically to create this interesting tension. It was one of the devices I used to catch the eye of the viewer, tricking the viewer into remembering the painting—even if it might only be this dissonant element they would remember, as in my painting *Thin Red Line* (opposite).

Split and Double Complementary Systems

The so-called split complementary system is a sometimes-overlooked way of organizing color into a harmonious system. Using directly complementary colors can sometimes be a bit "noisy"; the split system is more subtle. Rather than using the possibly jarring juxtaposition of opposite colors like violet and yellow, an artist will use the similar neighboring colors of the complement, thus "splitting" the complement and creating a softer landing for the viewer's eye. Often, the decision to use a split complement is intuitive on the painter's part and not planned, a nuance.

SPLIT COMPLEMENTARY

In this variation of the color wheel, the split complements of each color are indicated by the two prongs of the V shape: For example, by tracing the prongs of the V originating at yellow, you find that the split complements for yellow are blue-violet and red-violet.

Al Held's *Field Marker II* uses the split complementary system with several variations of blue-violet and red-violet acting somewhat as background elements to several floating yellow shapes that seem to have no real connection to anything. Notice the tension they establish with the violet.

Al Held, *Field Marker II*, 1991, acrylic on canvas, 72 x 84 inches (183 x 213.5 cm). Courtesy of Ameringer McEnery Yohe variants.

ANALOGOUS {ANY 5}

Here, a group of analogous colors has been selected from the color wheel.

In this painting, Ronnie Landfield makes visually arresting use of the harmony inherent in analogous colors.

Ronnie Landfield, *Into the Light*, 2010, acrylic on canvas, 91 x 93 inches (231 x 236 cm). Courtesy of the artist.

The other variation on a complementary color system involves using two complementary systems within the same composition—that is, a double complementary system. Generally speaking, the use of two sets of complements in the same painting may have great visual impact. Two forceful, highly charged assaults of color may capture the viewer and hold his or her attention. Sometimes, though, the appearance of this double complementary system may simply result from an accurate rendition of the subject matter the artist chooses. An intriguing color harmony may be a conscious choice, but it might also originate in an unconscious process of selection and execution.

The Analogous Color System

Analogous colors are colors adjacent to each other on the color wheel. Using an analogous color system, a painter might choose three, four, or five such colors; the illustration left shows a color wheel from which five analogous colors, ranging from green through orange, have been selected. The analogous color system is an important alternate way of thinking about color relationships, because there is a harmony inherent in similar colors. Choosing colors that are close to one another can be a safe bet when you're stymied about which colors you should use. You can clearly see the harmony resulting from analogous colors in Ronnie Landfield's painting *Into the Light* (below).

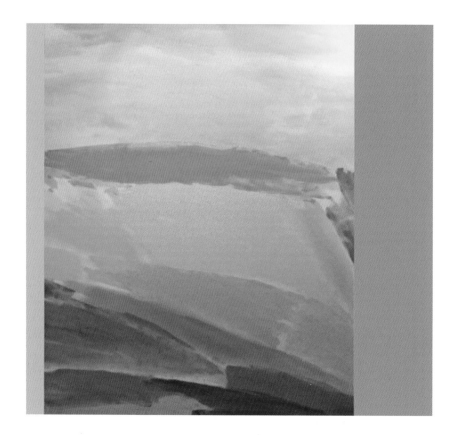

Before moving on, let's review: You have identified the hues on a color wheel and have seen that there are a number of ways of organizing the twelve basic colors to create groupings called systems. These systems provide means for creating harmonies and tensions that may hold the viewer's attention long enough to create a lasting memory. You have also learned a bit about the way some colors are made or mixed. Now let's look at what happens if some of the basic hues get mixed up with one another or with white or black.

COLOR MODIFICATION

Colors can be modified in two basic ways: (1) a color can be *neutralized* by mixing it with its exact opposite, or complement, on the color wheel, and (2) a color's *value*—its lightness or darkness—can be altered by mixing it with white or black.

Color Neutralization

Neutralization occurs when complementary colors are mixed together. For example, if you gradually mix red and green, you'll eventually reach the point where the resulting color is neither red nor green but a fully neutralized product of two complements, as shown in the illustration left. This can be done either by starting with red and gradually adding green or by starting with green and gradually adding red. As you add its complement to any color, that color's chroma—that is, its specificity or trueness—will diminish until, finally, it is no longer the color it was. This neutralization effect has important uses in painting, which I'll come back to in the next section, on modifying value.

When the complementary colors red and green are gradually mixed together, they are eventually neutralized—producing a color that is neither red nor green.

ARTFUL TIP Color Dominance

I want to give you a small warning that no one gave me at the beginning of my color-mixing career—which led to some big problems! When mixing colors, you've got to take into account that the three primary colors have varying levels of dominance. Yellow is the least dominant, or weakest, of the three: it doesn't have enough built-in power to dominate any color that's added to it—and red or blue will always overwhelm it. In practical terms, this means that you must bring a surprisingly small amount of red to the yellow to make red-orange, even less to make orange, and even less to make yellow-orange. If you try to make the secondary and tertiary colors the other way around—by bringing yellow to the red—you'll end up in trouble, because you'll have to add vast amounts of yellow to the red to achieve the desired result. The same goes for combining yellow and blue: blue is much more dominant, so bring the blue in small amounts to the yellow. The violet colors are a bit harder to balance, but I would advise starting with red and bringing the blue to it in small amounts, because red is the slightly less dominant color.

Constructing the equivalent of a color wheel on your palette is easy. Here's how to do it, using bismuth vanadate yellow, phthalo blue (green shade), and quinacridone magenta from Golden's OPEN line and working on a dry palette. To mix the colors, I use a small, paddle-shaped painting knife that mixes paint easily—almost like a brush but easier to clean. The mixing motion is fairly intuitive: it consists of a back and forth squishing motion, continuing until the color desired is obtained.

You'll notice that I have mixed large amounts of the secondary and tertiary colors—amounts equal to those of the primary colors. But I'm not being excessive or extravagant. It is always better to have too much mixed paint than not enough, and I've found that having a ready supply of the full spectrum of colors lets me comfortably take chances when developing neutrals, tints, or shades (see page 90). But with this quantity of paint available, it is crucial to constantly keep your palette in order.

1) Begin by placing a sizable dab of each primary color on the palette, spacing the dabs several inches apart—up to 8 inches if possible, or even farther apart if there's room on your palette. Notice that I put out a lot more yellow than red (magenta) or blue. That's because yellow, being the least dominant color, is so easily affected by the other colors.

2) Now place several small dots of blue paint between the larger blue and yellow dabs. Notice that the amount of blue paint decreases as you approach the yellow dab. These dots will be mixed

with the yellow to create the secondary color (green) and the two tertiary colors (yellow-green and blue-green). You'll also place dots of red paint between the red and yellow dabs—again, in diminishing quantity the closer you get to the yellow. These dots are only an approximation: you may need more or, more probably, even less. Start small. A good rule is to bring the dominant color to the less dominant—for example, a little blue and a lot of yellow for green and even less blue for yellow-green.

3) Now, begin mixing in both directions from yellow. You will have to adjust the quantities of yellow to bring your oranges and greens to the desired intensity.

4) When mixing colors with the little paddle-shaped knife, always remember to wipe off the knife before moving from one mixed color to the next. I use a lot of paper towels, but you may prefer to use a rag.

The center of the color wheel you've created will serve as one of the mixing areas of the palette. It's where the white will live, and where you'll mix the tints. I keep the black paint in a separate area outside the wheel, and this is where I mix the shades and the neutralized colors. The reason for this separation is to keep the danger of "mud" to a minimum. If shades and neutralized colors start to dominate the space on a palette, the painting produced from that palette may itself become muddy. But creating some mud is inevitable, so when mud begins to overwhelm my palette, I use a straight-edged painting knife to scrape away as much as I can. Don't let anything on your palette become so precious that you can't bear to scrape it off. (The same goes for the painting itself, but that's another topic!)

5) Continue by mixing your basic violet and then mixing the intermediary colors on either side of violet, adjusting hues as you go along. Violet is the opposite, or complement, of the least dominant color (yellow) and thus stands as the quiet anchor of the color wheel. Red-violet on one side and blue-violet on the other side of the violet each touch the respective primary colors.

6) Continue making adjustments as necessary. In these photos, I further adjust the greens to heighten their brilliance.

7) Now, using a longer, straight-edged painting knife, push the paint back and away from the center of your color wheel, piling up the mixed paint as much as possible without corrupting the colors. (Piling the mixed paint is easier on a dry palette because there is no thinning or spreading, as happens on a wet palette.)

Adding black to colors darkens them, of course, but a strange thing happens when black is mixed with yellow: an olive green color results.

The range of tints and shades can be imagined as a globe, with pure white at the "north pole" and pure black at the "south pole." Here are views of this globe from both perspectives.

Illustrations by Michael Van Patten.

Value Modification

Adding either white or black to a color changes its value. If white is added, the resulting color is called a tint; adding black produces what is called a shade. One way to visualize changing the value of a color is to imagine a dimmer switch attached to a very bright white light. The greater the level of the white light, the lighter the colors in a room would appear; lowering the light level would make them appear darker.

This is obvious, of course—that adding white will lighten a color and that adding black will darken it. When mixing colors, however, a caution is in order. As I say in the sidebar "Color Dominance" on page 87, colors have varying levels of dominance, and the same goes for white and black. White is the least dominant of all—even weaker than yellow. Although it may be intuitive to add white to a color when you want to make it lighter, it's a much better strategy to add the color to white, because every color, even yellow, is more dominant than white. The opposite is true of black. Because black is more dominant than any color, it should be added to the color in very small increments when you want to darken the color; otherwise, it may completely overwhelm the color very quickly. By the way, when black paint is added to yellow, something strange and wonderful happens. A new color appears—a kind of olive green, as shown top left.

Beginning painters often intuitively think that adding black to a color is the best way to create a shadow or other dimmer area within a painting. This can be done, of course, but it's not necessarily the best way of producing this effect. To understand this, you need to return to the idea of color neutralization discussed earlier.

First, though, I want you to imagine a globe of color in which pure white is at the "north pole" and pure black is at the "south pole." The figures left show such a globe, viewed from both the north (white) pole and the south (black) pole. As you can see, the tints of color become progressively lighter as they approach the north pole. Viewed from the south, or black, pole, the opposite is true, with the shades of color becoming progressively darker as they near the pole.

At the equator of this globe is a ring of the pure, unmodified hues of the color wheel. If you cut the globe in half at the equator, you would find the grapefruit-like half-sphere shown in the figure at top right. As you can see, the chroma (trueness or specificity) of the colors diminishes as you travel inward to the center of the sphere, as each hue is mixed to a greater and greater degree with its complement. Note that the equator is exactly midway between the poles, so no white or black has been added to the colors in this central "slice" of the globe. Yet at the very center, you find a completely neutralized color that is somewhat similar to the gray that's at the midpoint of the scale of value. And yet it's subtly different, for this neutral color is composed not of black and white, but of two complementary hues. It's therefore richer and more alive than a medium gray made only from black and white could ever be.

Understanding this is crucial when you're working on a painting and want to produce a lively effect. Say you've painted a red object, part of which is in shadow. One way of creating that shadow would be to mix black into the red. But a better way, producing a more lifelike effect, would be to add green to the red in greater and greater increments as the shadow deepens. Can you see how this would produce a shadow that's more genuinely shadow-like?

MIXING COLORS

Mixing color can be almost as much fun as painting; it flirts with magic—or maybe with alchemy. A painting starts with the initial choice of colors that you'll use to make many other colors. This starting point is a called a palette—the word referring, in this case, to the organization of color rather than to the surface (such as a wood or paper palette) on which the paint is placed. For learning purposes, a very limited palette—the smallest number of colors from which you can mix a wide range of other colors—is best. What happens while mixing paint is a practical application of what I have talked about in this discussion of color theory. As you'll see, the basics aren't difficult.

So let's begin with a very limited palette consisting of the three primary colors plus black and white. Sticking with the readily available paints made by the Golden company, I suggest two options: The first is to use the faster-drying Golden Heavy Body paints on a wet palette. If that's your choice, start with tubes of primary magenta, primary cyan, and primary yellow, plus carbon black and titanium white.

Your other option is to choose a three-color group from Golden's OPEN line of slow-drying acrylic paint, along with carbon black and titanium white. Golden offers a Try Color Set of 22ml tubes of three colors functioning as primary colors: Bismuth Vanadate Yellow, Phthalo Blue (green shade), and Quinacridone Magenta. The paints in this useful starter set are shown at right. The sidebar "Creating a Basic Palette" (pages 88–89) explains the color-mixing procedure using these paints.

Of course, color mixing doesn't just happen on the palette. When you're actually working on a painting, you'll find that you'll also mix colors directly on the canvas with your brush. And mixing paint directly with a brush on the palette allows you to quickly create the exact color you desire and bring it to the painting.

Once you've read the section on color theory and have mixed your first palette of colors, you'll want to apply what you've learned by actually painting a painting. To start, I strongly recommend finding a subject that's doable—one

(Continued on page 94)

The color globe's equator is ringed by the pure, unmodified hues of the color wheel. If you slice the globe in half at this circle, you see how each color is gradually neutralized by the opposite, complementary color on the wheel.

Illustrations by Michael Van Patten.

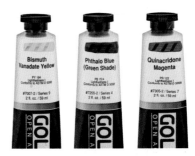

Bismuth vanadate yellow, phthalo blue (green shade), and quinacridone magenta are the three primary colors in the Golden OPEN line.

Sometimes it's most convenient to mix a color directly with your brush.

Painting a simple still life will quickly show you how complex and intriguing the colors of real-world objects can be. Here are the stages I went through in creating a small (8 x 8 inch) still life of a lemon and apple.

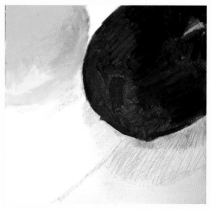

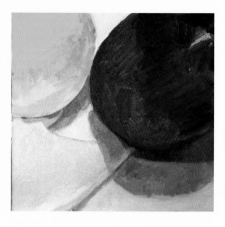

1) Begin by sketching a quick "value drawing" of the still life directly on your canvas. Your goal here is not to produce a beautiful finished drawing but rather to indicate the basic shapes of the objects and the areas of lighter and darker shadow.

2) Looking at the colors of the still life, state the obvious first—kind of like writing that thesis sentence you were taught to do when you learned how to write compositions in high school. Red and yellow are the colors, so paint the yellow shape and the red shape, also roughing in some of the dark and light you took note of in the value drawing. (By the way, although it appears that the apple's color here seems to fall more in the red-violet range than "pure" red, I in fact used Golden's Quinacridone Magenta combined with carbon black. In the Golden OPEN paint line, the slot for the red in a primary triad is taken by Quinacridone Magenta, raising the interesting question, What does red look like? It might be better to ask, What color mixes like red?)

3) Develop the red and yellow further, always focusing on exactly what you see. In the apple I used for this exercise, I noticed that the red was much darker than what I might have expected—almost purple in some spots and very dark, almost blackish, in others. Just as interesting was my discovery of the third color of the primary triad—blue—in the shadow cast by the fruit.

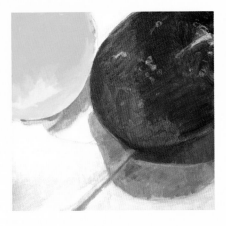 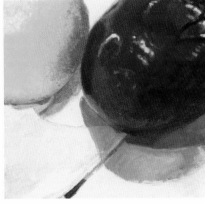

4) Continue to find and to paint the variations and nuances of color in the three primary colors that make up the composition. And keep looking, too, for the many other shapes within the simple shapes of the fruit and the piece of white cloth—shapes indicating shadow, reflection, texture, and the unevenness of the forms' surfaces.

5) Go back now and reexamine areas where you made "color discoveries"—like the oranges in the lemon and the depth of shadow on the apple shape. You'll have to make some colors lighter and give some colors thin coats of darker paint in order to create the illusion of three dimensions.

6) As you approach the completion of the painting, pay even greater attention to the subtleties of light and dark. In order to bring the painting off, move through the whole painting with a rather light touch. Don't focus all your attention on a single passage, no matter how important you think it is. Keep thinking of what you're doing as painting—that is, making shapes and smudges of color. If you are lucky, you may be able to fool someone into thinking they're looking at an apple and a lemon.

Elektra Rose's use of more than just a single color in these studies of a clementine gives us two delicious visual morsels.

Above: Elektra Rose, *Orange Inside*, 2009, acrylic on linen, 12 x 12 inches (30.5 x 30.5 cm). Courtesy of the artist.

Multiple coats of Golden's Polymer Varnish with UVLS (ultraviolet light stabilizers) will make fluorescent colors lightfast.

that presents problems that seem possible for you, a beginner, to solve. You can learn an awful lot about color by painting even a very simple subject—such as the still life of the apple and lemon in the sidebar "A Simple Still Life" (pages 92-93). If you really look at a lemon and apple, you'll see that the fruits aren't just yellow and red. You'll perceive a wide range of colors—including some you may not expect. That's why it's important always to have the secondary and tertiary colors mixed and ready to go when you begin to paint—as well as black and white to alter value and suggest light and shadow when needed.

The paintings are one student's responses to the exercise of painting a small, simple still life. The painter, Elektra Rose, was a student of mine back in 2009 when I asked the class she was in to do a painting of a clementine. I handed out clementines to everyone, and these were Elektra's very successful solutions to the problem.

Eventually, you may want to expand your palette beyond the simple palette recommended here. Expanding one's palette is a very personal matter. I constantly find myself ogling the beautiful colors in catalogs and on the shelves of art supplies stores. In order to keep my sanity—and to keep my budget within reason—I always ask myself, Can I *easily* mix this color? Where will the color fit on my palette? Will it really enhance my choices when painting? And, finally, Can I get along without it? Most of the time I make it out of the store with my credit card safely in my wallet. I find that "less *is* more," and so I generally stick to the basic five-pigment palette (three primaries plus black and white) that I've recommended to you.

There are a few other colors, however, that may be worth your consideration. If you have begun with a limited palette with no phthalo colors, you may wish to add a phthalo blue or phthalo green. These colors are products of science and possess an intense brilliance while remaining colorfast. When blended, phthalo colors produce richer greens, violets, and shades or tints of tertiary colors than can be achieved with nonphthalo colors.

If you're not too concerned about lightfastness, try adding some fluorescent colors to your palette. When it interacts with some pigments, ultraviolet light acts like bleach, gradually robbing them of color, and fluorescent colors are especially prone to this degradation. At present, unprotected florescent colors are, without exception, not colorfast and will ultimately fade to white. However, the Golden Company ran tests to see how well its fluorescent colors held up when protected by multiple coats of the UV-shielding varnish shown left. To the delight of many artists, Golden's researchers found that the brilliance of the colors remained unaffected over extended periods. The downside to putting this varnish shield on fluorescent paint is that if too much is applied the paint will no longer glow under "black light" (which of course is UV light).

Above: Elektra Rose, *Orange & Peel Study*, 2009, acrylic on linen, 12 x 12 inches (30.5 x 30.5 cm). Courtesy of the artist.

06 YOUR VISION AS A PAINTER

Choosing how and what to paint seems like a difficult decision, but finding a direction is not always the result of some flash of inspiration. Pop artist Andy Warhol was constantly asking other people, "What should I paint?" Once, while visiting the late New York art dealer Ivan Karp at Ivan's upstate New York home, Warhol posed the question to his host, who rather flippantly responded, "Paint cows, Andy." (Ivan happened to be looking at some cows grazing at the time.) That was the genesis of Warhol's successful series of cow paintings and prints. Sometimes choosing a subject matter at random can lead you in a productive direction.

In fact, artists' choices of subject matter often result from some accidental confluence of events or a casual remark about something trivial—or something definitely not poetic. In 1981, shortly after Ivan began to represent me at his OK Harris gallery, he called me and told me to come to the gallery to pick up a painting of mine that he didn't want. Upon my arrival, Ivan said, "You can take this painting home. It doesn't work as well as the ones with water. There's no water in it." To my bewilderment, he continued: "Paint water. Water sells." I have painted water from that day on. The first painting of mine that OK Harris sold was a water scene. It sold the third day they had it. (I should add that I really love to paint water.)

Beware of your own expectations when choosing an artistic direction. Many of life's disappointments are caused by our own faulty expectations. Probably the most common goal for a beginning painter is to try to create some sort of a recognizable rendition of a reality either remembered or observed. The hope is that you'll communicate your perception to someone else. But when this is your goal, the question "What is it?" can be devastating. You'll have to thicken your skin and get used to this. The same piece of art may communicate different information to each viewer. The artist and the viewer together make the art experience, and that experience is not predictable.

Opposite: James Van Patten, *Looking on the Other Side*, 1981, acrylic on canvas, 48 x 64 inches (122 x 162.5 cm). Private collection, New York.

My first direction was as an abstract artist. Though it has landscape elements, *Plane Plain Hill* is basically an abstract work.

James Van Patten, *Plane Plain Hill*, c. 1970, charcoal and acrylic on raw canvas, 48 x 54 inches (122 x 137 cm)

CHOOSING A STYLE

I often tell friends that I am a failed abstract artist. I am not kidding. But I got tired of explaining myself, and so I eventually took another direction—one that I am not sorry for but that was not my first choice, as you may have noticed from some of my earlier works reproduced in this book. One of those is the work called *Plane Plain Hill* (above).

You should think about the style of painting that suits you best—and that you think will best enable you to communicate what you want to share. But you should also be aware that, if you need to, you can change direction later on. With that option in mind, let's look at some of the styles you might choose to work in.

HYPERREALISM

The movement in painting that surprised the art world with images so sharp and clear that they seemed photographic was first called photorealism but is now more often referred to as hyperrealism or simply as new or contemporary realism. The English author John Russell Taylor coined yet a different moniker—

Left: Hyperrealist painter Rod Penner chose an abandoned gas station for his work *J+H Station*.

Rod Penner, *J+H Station*, 2012, acrylic on canvas, 36 x 54 inches (91.5 x 137 cm). Courtesy of the artist.

Below: My painting *Great Swamp* is of a natural subject, but the scene has an abject quality found in many hyperrealist paintings of human-altered landscapes. A close friend, also a hyperrealist, once said my work is creepy.

James Van Patten, *Great Swamp*, 1989, acrylic on linen, 48 x 72 inches (122 x 183 cm). Private collection.

Hyperrealist painter Simon Hennessey specializes in portraits, many of which include reflective eyewear. There are a few exceptions, but most hyperrealist painters use reflection as a subject matter in their work.

Simon Hennessey, *On Reflection*, 2011, acrylic on linen, 47¼ x 47¼ inches (120 x 120 cm). Courtesy of the artist.

exactitude—in the title of his 2009 book *Exactitude: Hyperrealist Art Today*. This is the place where I find myself slotted by those who need to classify my work, and in this discussion of stylistic direction, I'm starting with hyperrealism because this is where I have the most firsthand knowledge.

Many in this group of painters are obsessed with subjects that are ordinarily overlooked. Just as Andy Warhol, back in the 1960s, asked us to look at soup cans as if we had never seen them before, today's hyperrealist painters ask the viewer to look at pickup trucks, mobile homes, derelict cars, washing machines, or abandoned gas stations—as in Rod Penner's *J+H Station* (at the top of page 99).

Some hyperrealist painters choose human faces—in extreme close-up, on huge canvases—as their subject. In my case, I've focused on natural landscapes that one would not ordinarily bother to look at, or not look at for long: places like swamps, stagnant sloughs, and floodplains. Many hyperrealists (including myself) are intrigued by shiny surfaces. Actually, they're following in a long tradition of artists who have captured viewers' attention by creating the illusion of mirrors or other reflective surfaces—a tradition that dates back at least as far as the early Renaissance. Hyperrealist Simon Hennessey combines portraiture and the depiction of reflections in the painting opposite.

So why choose the hyperrealist path? For one thing, it saves you the trouble of having to explain what an image is, since viewers will recognize the subject and not have to ask. Still, viewers might be curious as to why you've chosen your particular subject matter. If your work is like mine or that of many of my colleagues, they might wonder why in the world you chose to paint a muddy patch in front of a deserted service station, or a swamp, or the back of a nondescript old building. My answer is that I just want the viewer to look at a part of the world that's gone unnoticed. Look again. Pay attention!

To be frank, doing this kind of work is work. It is both time- and labor-intensive. I sometimes joke with friends that I am one of the few people I know who still works for under a dollar an hour. Usually when I'm working on a passage in a painting, I know that I will repaint that same area several times, building on what I have done, until it reaches the point where I can move on—only to repeat the same process over again a few inches away.

PAINTERLY REALISM

The term *painterly* refers to the brushwork in a painting, and in painterly realism, the process of working through the painting is usually apparent in the finished work, with the transitions from place to place often having clear separation, sometimes in plane-like layering, as can be seen in Marcia Burtt's painting *Reflections* (page 103). This is not a new or even recent style of painting. It is easily traceable at least as far back as the seventeenth-century Dutch painters like Frans Hals and Rembrandt, who allowed the stroke of the brush to be visible, so to think of the painterly style as modern is not really correct.

Until recently, fast-drying acrylic paint hindered realists from doing the kind of blending and reworking of paint that must be done to develop believable imagery in a painterly style. Now this is no longer necessarily a problem because of the extended open times and reopening possibilities offered by Golden, Winsor & Newton, and Atelier paints—and other brands that inevitably will soon be available. So painterly realism is now a live option for acrylic painters.

There is much in common between hyperrealism and painterly realism. The hyperrealist just keeps painting longer and usually does away with most of the evidence of the process. Though my style is usually hyperrealist, I have occasionally taken a more painterly approach, as you can see from the small life study *Figure with Gray Wall* (below) that I did several years ago as a class demonstration. Here, I allowed my brushwork to show because I was interested in establishing value and color, and much of the process of the work remains apparent in the finished piece. If I had been working in my usual style, I would have used a photograph or several photographs as references to provide me with all the visual information and would not have been dependent on my perceptions as they existed over a span of time. I would have frozen time. This is an important difference between the hyperrealist and painterly realist styles.

I let my brushwork show in this small study.

James Van Patten, *Figure with Gray Wall*, 2009, acrylic on linen, 12 x 12 inches (30.5 x 30.5 cm). Collection of the artist.

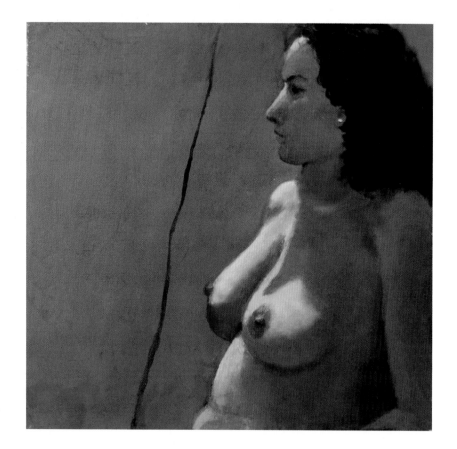

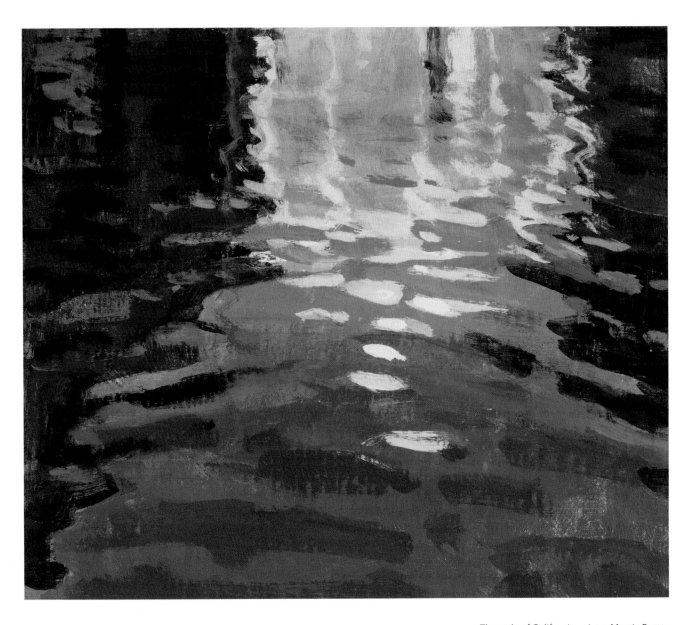

The style of California painter Marcia Burtt, who specializes in landscapes and coastal scenes, can be described as painterly realism.

Marcia Burtt, *Reflections*, 2012, acrylic on canvas, 10¾ x 12 inches (27.5 x 30.5 cm). Courtesy of the artist.

Paul Cézanne combined the skill of a more traditional realist with the insights that the impressionists developed about showing a moment of light and color in time.

Paul Cézanne, *Still Life with Apples*, 1893-1894, oil on canvas, 25¾ x 32⅛ inches (65.5 x 81.5 cm). J. Paul Getty Museum, Los Angeles.

Is one realism better than the other? Not necessarily. The viewer coming upon a painting by a hyperrealist has the same first response he or she would have at seeing a photograph, immediately focusing on the subject of the image. But then, realizing that this seeming photograph is really a painting, the viewer goes through a readjustment of perception and may even question his or her powers of perception. And then that viewer begins to wonder how paintings like that are created.

You could argue that a painting that immediately establishes itself as a painting gives the viewer a greater gift, by letting the viewer in on the process from the start. Of all the painters who have let us in on the actual, magical act of painting, Paul Cézanne may be the greatest. Although he worked primarily in oils, the acrylic painter can learn much from him. He built paintings with slabs of paint leaning into each other to form a visual structure that welcomes the viewer into a new reality. Cézanne began thinking of the world as being made of planes of value and color, simplifying the world to an almost geometric reality—a way of creating images that eventually resulted in the cubists' revolutionary vision. When you have spent some time with your acrylics and are beginning to feel comfortable, you might try to emulate Cézanne, laying stroke over stroke to build not just an image but a tapestry of textures.

Other artists who used reality as a springboard for a personal vision were Henri Matisse and André Derain. At times they would assign unexpected colors to objects and would simplify or distort shapes. Painterly realists don't have to "obey" perception absolutely, so as you mix your own colors, why not sometimes use a color that's a little brighter than what you see, for the joy of doing so—or one that's duller for the subtlety of the resulting effect? Change shapes, too. Be arbitrary. Create a puzzle for the viewer. You have the brush, and you are in control.

In paintings like *Charing Cross Bridge, London*, André Derain used perceived reality as a springboard for the artist's imagination. Using reality as your springboard, try to imagine an acrylic work with unexpected color.

André Derain, *Charing Cross Bridge, London*, 1906, oil on canvas, 31¾ x 39¼ inches (80.5 x 99.7 cm). Musée d'Orsay, Paris; photo by Art Resource, New York.

This untitled oil painting from 1964 belongs to my first abstract period.

James Van Patten, *Untitled*, 1964, oil on canvas, 48 x 56 inches (122 x 142 cm).

ABSTRACTION

Many of the painters of the early-twentieth century wandered away from realism. They began to produce paintings with components that were not understandable as objects, people, or places. Some of their paintings have shapes that remind you of things you know—but not quite—or contain scraps of the world seen in new and strange contexts.

Pushing the boundaries of painting remains an appropriate goal for anyone with a paintbrush and an idea that wants to be shared. At its most basic level, abstract painting is a celebration of color and the other elements of visual experience.

If you think you want to make abstract paintings, how should you start? I would recommend that you first look at a lot of abstract art—which is very easy to do on the Internet, if you don't have easy access to museums or galleries.

As you can see from this somewhat later work of mine, *Almost Two Squares*, I changed direction, beginning to incorporate landscape elements into my abstract work. If you want to, you can change direction, too.

James Van Patten, *Almost Two Squares*, 1969, acrylic on canvas, 30 x 59 inches (76 x 150 cm).

Kazimir Malevich's *Morning in the Village after Snowstorm* is an abstract composition with recognizable elements. Now, over one hundred years later, try to envision altering perceptions of reality. Try to reduce known objects into their geometric equivalents as Malevich did in this painting, but this time do it with acrylic paint.

Kazimir Malevich, *Morning in the Village after Snowstorm*, 1912, oil on canvas, 31½ x 31½ inches (80 x 80 cm). The Solomon R. Guggenheim Foundation/Art Resource, New York.

ARTFUL PRACTICE Composing Without Using an image

One way to start doing some nonrepresentational "thinking" is to draw a rectangle or square and then break it up into a series of small and large shapes:

Keep making thumbnails until you have one or two images that you wouldn't mind investing some time in. Then scale up your thumbnail (see the instructions for enlarging, on pages 128–129), transferring your little drawing to a suitable painting surface. Although I don't know for sure, I would guess that abstract painter Moses Hoskins, one of whose works appears on page 109, works in a manner similar to what I've just outlined, generating many ideas in the process.

If you are courageous, start adding color, and do your abstract painting right away. If you are a little cautious, work out some possible color schemes using colored pencils or some acrylic paint thinned like a watercolor wash or some of the new acrylic markers. (This might be the time to review some of the material on color systems in chapter 5.) If the shapes you have created evoke a sense of space, try to use a combination of colors that reinforce the spatial illusion. See what the composition is like if you mainly use analogous colors or maybe a secondary triad. What would happen if one of the shapes were to incorporate some unexpected texture through the use of one of the gels or grounds mentioned in chapter 1?

1) First, draw the rectangle. Let's call this rectangle the picture plane.

2) Then draw a line from one random spot on the rectangle's edge to another random spot on another edge. You now have two shapes in a picture plane.

3) Keep on going, drawing lines and taking the time to look carefully at the proportions you're setting up. Do this until you have something interesting.

4) You may even create one or two shapes whose edges do not meet the edge of the picture plane. Some will be enclosed by the borders of the picture plane, some will move off the edges.

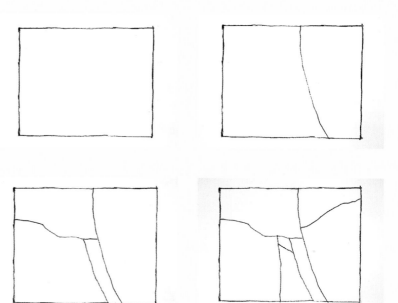

In his abstract works, Moses Hoskins constantly experiments with combinations of shape, line, and color. The idea unfolds as the painting develops.

Moses Hoskins, *Untitled*, 2008, acrylic and other painting and drawing mediums on canvas, 32 x 36 inches (81.25 x 91.5 cm). Courtesy of the artist.

I can divide the years I spent working as an abstract painter into two periods. During the first, I was enamored with shape, both geometric and nongeometric, and used intense colors and a lot of thick oil paint. In the second period, I began using some of those abstract shapes combined with elements of landscape. These paintings were usually made with thinner acrylic paint. I show a few pieces from my own ancient history on pages 106 and 107, as examples of ways to paint nonobjectively.

CHOOSING A SUBJECT

If you decide to paint in a realist style, whether hyperrealist or a more painterly realism, you're immediately faced with another choice: What do you paint? There are several large categories—sometimes called genres—that the images of representational painting fall into. In this section, I'll cover three traditional genres: still life, figure painting (including portrait painting), and landscape. There are also some paintings—of historical events, for example—that bridge categories. A student of mine who was also an attorney was ingenious at finding material worthy of painting in unexpected places. The apparently abstract painting above is actually a rather accurate rendition of a boxy briefcase, used by trial lawyers, seen from the top. Ask yourself: What genre is this?

Jo Ellen Silberstein's *Black Litigation Bag Series #1* is a great example of a painting that crosses style and genre boundaries.

Jo Ellen Silberstein, *Black Litigation Bag Series #1*, date unknown, acrylic on canvas, 18 x 24 inches (45.5 x 61 cm). Courtesy of the artist.

No matter which category you choose (and you may choose to work in several), you'll share common ground with other realist artists, trying to communicate in two dimensions your relation to and perception of things that exist in three dimensions. That bit of magic has driven artists from prehistory until the present day.

STILL LIFE

Still life is one of the great classical genres. I suggest spending some time looking at works by the great still-life painters, including Jean-Baptiste-Siméon Chardin, Willem Kalf, Paul Cézanne, Giorgio Morandi, and Ralph Goings. Study how they saw the usually rather common objects that captured their attention. Are you attracted to the subject matter? Repulsed by it? Ask yourself why. As you look at the paintings, also think about how you might approach the subject matter differently—or how other artists' still lifes might influence your own work. Still life is a good genre in which to start off your artistic exploration. The paintings opposite, which were done by students of mine, show how much can be achieved by persons learning to be acrylic painters.

As you search for something to paint, you may want to consider stretching the definition of still life. Why can't the dishes in a place setting just before a meal or the dirty dishes stacked in the sink afterward be subjects for a still life? How about the jumble of shoes or boxes in the back of your closet? Use the viewfinder you made from a piece of paper (see page 60) or the camera on your phone to find some overlooked "still lifes" close to you, and make some notes in the form of little sketches.

Many beginning artists start by painting still lifes. These two works by former students of mine demonstrate how much can be achieved by beginners working in this genre.

Left: Elena Goldstein, *Oranges and Jelly Beans*, 2011, acrylic on canvas, 14 x 14 inches (35.5 x 35.5 cm). Courtesy of the artist.

Below: Elektra Rose, *Three Pears*, 2010, acrylic on canvas, 20 x 10 inches (50.8 x 25.4 cm). Courtesy of the artist.

My painting *Breakfast* is a still life based on ordinary, everyday experience.

James Van Patten, *Breakfast*, 2012, acrylic on canvas, 16 x 24 inches (40.5 x 61 cm).

Or go back to the simple arrangement of an apple and a lemon that I discussed when talking about color in the previous chapter. Make your own apple-and-lemon arrangement and, using the viewfinder, do some small sketches of these objects as seen from different angles. After you've made a few sketches, choose one that pleases you and that you think could serve as the basis for a still-life painting. When making your choice, consider the space around the objects as well as the positions of the fruit. This so-called "negative space" can heighten a painting's impact. Also consider the shadows, and imagine the composition if the light source were changed and the shadows differently cast. Should the image you've drawn from looking through the viewfinder be cropped more closely? More loosely? Do you think it would be possible to do a whole series of paintings just of these two pieces of fruit?

When searching for the subject for a still-life painting, also consider the various elements of visual experience covered in chapter 4. Take one of the elements and use it as a guide when looking around. Let's say you choose texture. Gather a number of interestingly textured things on a walk outside or around your house. When you have collected a pile you like, arrange the objects into a still life. Shine some strong light on the arrangement, and see what it looks like. Now look at it from several angles, and do some little drawings using the viewfinder

to set up the compositions. If you get something you like, you have a place to start a painting. Even ask yourself whether you could make the surface of the painting a statement about texture. You can go through this same process for any of the other elements, letting your imagination build an idea until you just can't wait to start painting.

Trying to stay on the alert for a ready-made still life, I placed a hot cinnamon bun on a glass dining-room table one morning, and there it was: my still life. Of course, what I'd really been thinking about was breakfast, but I quickly got my camera and took several shots of the cinnamon bun, coffee cup, and cutlery and later developed the painting shown above from one of those photos. I detail my process and the technique I used for this painting beginning on page 124.

FIGURE PAINTING AND PORTRAITS

Working from the human figure is one of the most satisfying things that an artist can do—but it can also be one of the hardest. One reason it can be so hard is that we think we know what the human body looks like. But when you begin working on a figure study or a portrait, you may quickly find that some of your unconscious assumptions are incorrect—and that the image you're making contains what I earlier called inadvertencies (see page 80). At that point, you'll have to ask yourself, What am I really seeing?

Let's begin with an exercise that isn't too threatening. If it isn't too cold in your room, take off a shoe and sock, and look at your foot. Get out that viewfinder, and look at your foot through the viewfinder. Find at least part of your foot that seems interesting, and make some sketches of what you see. Choose a drawing that pleases you, and transfer it to a small canvas to begin your first life painting.

Now, what about the nude? Painting the nude is not an emotionally neutral pursuit. But the anticipated embarrassment disappears as soon as you become involved in the act of painting. Painting a nude figure is about color, shape, value—the same things that painting a still life is about. Pay attention to what is in front of you, and be there in the present. Any feeling of discomfort goes away as soon as you start painting the shapes and become aware of the complexity of the color. When my students are painting from the nude figure, I always suggest painting more color than what they may actually see. This slight divergence from perceived reality can produce some wonderful results, as the painting by my former student Elektra Rose (on the following page) shows.

When doing figure studies, I've developed a couple of helpful tricks. If you are struggling with, say, the angle of an arm or leg, take your pencil or brush, sight it—or hold it out in front of you so that it seems to rest on the desired angle in your view of the figure, and then check the angle against your painting. If you're having problems with foreshortening—the distortion in perspective caused by viewing a shape from the end rather than the side—use your pencil or brush as a measuring tool, checking the visual length of the foreshortened shape against

This figure study by Elektra Rose, done
while she was a student, shows how the
addition or intensification of color can liven
up a nude figure study.

Elektra Rose, *Square Figure*, 2010, acrylic
on canvas, 10 x 10 inches (25.4 x 25.4 cm).
Courtesy of the artist.

some other reference point in the subject. For instance, if you're painting a reclining figure but seeing it from the feet end, the feet will appear much larger than the body's other forms. So visually measure all the shapes in this way, and using this same technique, check other passages in your visual field to see if they are in the same proportions as the shapes in your painting.

Of course, you don't have to worry about any of this. If you like, you can just do what seems right to you. Modern art allows you to break the rules. Picasso reportedly said, "It took me four years to paint like Raphael, but a lifetime to paint like a child," so if you want your work to have a childlike look, go for it. There are some great books about anatomy, but I would rather see a beginning painter find the joy of discovering the figure and worry about perfection later, if at all.

LANDSCAPE

I sometimes refer to landscape painting as "deep spatial illusion painting"—a category that's actually a little broader than landscape in that it also includes some paintings of interior spaces. The common ground is the creation of an illusion of a third dimension on a flat, two-dimensional surface, and many of the same issues arise whether you're painting an outdoor or indoor scene. This last, large category may be the most ambitious of the three genres in that the painter is trying to create the illusion of great depth. But that depth isn't infinite. As a landscape artist myself, I am always keenly aware that any painted landscape is just a tiny fraction of what you see when you look at an actual landscape.

One of the great discoveries of Renaissance artists was a method for drawing accurate linear perspective, a discovery credited to the architect and sculptor Filippo Brunelleschi, best known for designing the dome of the Florence cathedral. The painter Masaccio used this device in the 1420s in a painting of the Holy Trinity (right), which shows the crucifixion against a background of deep interior space.

Although you can use linear perspective—especially multipoint perspective—to construct quite believable renditions of many kinds of scenes, in my opinion there is no real substitute for the firsthand experience of space—interior or exterior. In the nineteenth century, the impressionists began painting outside in their attempt to capture a moment, freezing an instant of light as they experienced it. And in that instant, they also tried to freeze the qualities of color and light that gave depth and dimension to the painted landscape. The painting by Édouard Manet of his fellow impressionist Claude Monet in Monet's floating studio (page 116) reveals just how important capturing the moment was to these young painters. Some impressionists used photographs to capture that fleeting instant and keep it long enough to understand and truly replicate the magic of a moment.

Masaccio's *The Holy Trinity*, in the church of Santa Maria Novella in Florence, Italy, is one of the first instances in which an artist used linear perspective.

Masaccio, *The Holy Trinity*, c. 1427, fresco, 263 x 125 inches (668 x 317.5 cm). Santa Maria Novella, Florence.

Édouard Manet's painting of his colleague Claude Monet at work in his "studio boat" shows just how dedicated the impressionists were to getting out of doors and capturing the moment.

Édouard Manet, *Monet Painting on His Studio Boat*, 1874, oil on canvas, 32½ x 39½ inches (82.7 x 105.0 cm). Neue Pinakothek, Bayerische Staatsgemäldesammlungen, Munich; photo by Art Resource, New York.

Trying to produce interesting work in the shadow of such precedents is something I can't even allow myself to think about, so I instead spend my days thinking about all the little marks and dabs and spots that make up the vision before me. I can handle dabs and smudges and streaks and smears much more easily than the vastness of space. I somehow know that I will ultimately create a believable illusion of space, provided I can keep myself in the moment, focused on my brush. In other words, thinking about space is what I do before the painting starts and then again after most of the illusion is figured out.

ARTFUL TIP Creating Spatial Illusion

Over the centuries, artists have developed several means for creating the illusion of receding space within the picture plane. Here are examples of several of these methods. As you'll see if you study these images carefully, more than one method may be used in a single picture.

Converging Diagonal Lines

In my painting *Catskills*, naturally occurring elements of the landscape recede in space in an almost linear fashion. I have drawn lines over the work to suggest the movement the eye takes into this deeper space.

James Van Patten, *Catskills*, 1991, acrylic on linen, 48 x 72 inches (122 x 183 cm). Private collection.

Overlapping Shapes

In Davis Cone's *Cozy/Rainy Day*, you get a sense of depth and distance just by looking at how one car covers part of another, which conveys that the overlapped car is farther back. (This painting also shows the converging-lines device.)

Davis Cone, *Cozy/Rainy Day*, 2003, acrylic on canvas, approx. 28¾ x 47 inches (73 x 119.5 cm). Courtesy of the artist.

Relative Positioning on the Picture Plane

Painters can also exploit our automatic tendency to think of things just in front of our feet as being close while things higher up in our field of vision are farther away. That's what I did in my painting *Above the Dam*. The tree shapes above the small band of pale blue at the center of the composition are read as being quite distant simply because of this slight rise in elevation.

James Van Patten, *Above the Dam*, 2003, acrylic on linen, 36 x 54 inches (91.5 x 137 cm). Collection of David and Laurette Van Patten, Seattle, WA.

Relative Size

The remains of water lilies are depicted from the upper left to the lower right corner of my painting *Over the Edge*. In the real world, all of these plants are about the same size, but the plant in the lower right is depicted as much larger than the plants farther up the composition, conveying a sense of distance.

James Van Patten, *Over the Edge*, 2009, acrylic on linen, 48 x 64 inches (122 x 162.5 cm).

Weakening of Color Intensity

Looking at my *Late Light*, you immediately accept that the hills at the upper right are in the distance. The less intense, light greenish-blue color reminds the eye that light reflected off minuscule particles of water and dust in the air creates a visual scrim, making distant things less clear. This technique of creating the illusion of depth is sometimes called atmospheric perspective.

James Van Patten, *Shadow and Fog*, 2005, watercolor on paper, 10 x 13 inches (25.4 x 33 cm).

07 ACRYLIC PAINTING TECHNIQUES

Sometimes when I hear the word *technique*, I get defensive. I don't want anyone to tell me how to do anything—even if I don't understand how to do it. I am sure this is the same personality trait that keeps me from reading the directions until all else fails. So if you're feeling a little antsy about a chapter on acrylic painting techniques, believe me, I know how you feel.

By technique I simply mean the ways a blank canvas or some other surface can be transformed into the unique expression of mind and hand called painting. Artists sometimes want color to be thin, sometimes heavy, and sometimes so tactile it almost moves off the picture plane. There is a technique to help you realize each of these desires. A work of art may need very straight, precise edges and lines—another technique. Or an artist might want to build a composite of paint and textured paper or other materials. Or to use a combination of acrylic paints and acrylic mediums, as well as other painting and drawing mediums, as Moses Hoskins did in the work on page 122. There are techniques for these approaches, too.

Eventually, you may combine more than one technique or even develop a technique all your own. It is very possible that if you keep painting long enough, someone may walk up to one of your works on a gallery wall and say, "I recognize whose technique that is." It will be yours.

I hope to provide you with as many paths as possible to reach the results you want. The goal of technique is your success, comfort, and joy. If joy isn't a by-product of your work, then something is not quite right, and there is something missing in what we are experiencing together. Don't misunderstand me: Doing a painting can be hard and, to some extent, frustrating. It is not an accident that they call painting artwork.

Opposite: Marcia Burtt, *Above the Falls, Walking R*, 2011, acrylic on canvas, 18 x 13 inches (45.5 x 33 cm). Courtesy of the artist.

Adoration of the Magi was never finished, so it mostly consists of the underpainting.

Leonardo da Vinci, *Adoration of the Magi*, 1480-1482, oil and tempera on panel, 95 ⁷⁄₁₀ x 96 ⁸⁄₁₀ inches (243 x 246 cm). Uffizi Gallery, Florence.

There's no need for an "acrylic painter" to restrict himself or herself to just that single medium. In his abstract compositions, Moses Hoskins uses acrylics in combination with other mediums.

Moses Hoskins, *Untitled*, 2006, acrylic and other painting and drawing mediums on drop cloth, 26 x 32 inches (66 x 81cm). Courtesy of the artist.

UNDERPAINTING

The term *underpainting* means just what it sounds like: it's an initial stage of painting that will eventually be under—fully or mostly obscured by—the finished work. The most important function of underpainting is to establish the values and levels of contrast among values that will appear in the completed painting. When starting to paint, people tend to be a bit timid, and this shyness commonly results in weak, somewhat washed-out values. Underpainting can help combat this tendency. When underpainting, I usually start out by finding the darkest dark and the lightest light, painting those areas first and then gradually working toward the mid-tones.

MONOCHROME UNDERPAINTING

The most common underpainting is monochrome, which means "single color." As a boy, I was taught always to do a complete underpainting first, usually using raw umber. This classic approach can be seen in some Renaissance work, and it is still a useful method for approaching a work. I have found that umber underpainting is especially useful for portraits and other figurative work, because it saves time when applying the later layers of color. By building a complete value study of the face or figure in dark browns and pale creams, you'll already be establishing some of the color that may appear in the finished piece.

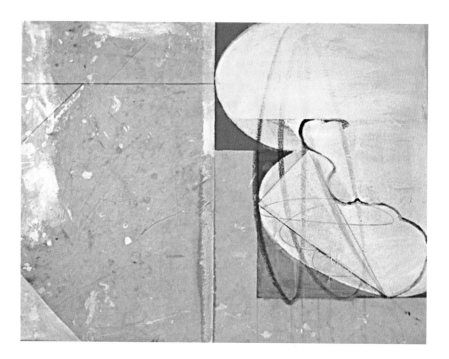

These three stages of the small figure study of mine called *Figure with Gray Wall* show how I began the grisaille underpainting by concentrating on the lights and darks (far left) and then worked on the mid-tones (center). At right is the finished work.

James Van Patten, *Figure with Gray Wall*, 2009, acrylic on canvas, 12 x 12 inches (30.5 x 30.5 cm). Collection of the artist.

GRISAILLE

An alternative to using umber is to work in black and white paint to create the darks, lights, and all the shades of gray in between. This is also a traditional method of underpainting, and it has a name that you should include in your vocabulary: *grisaille*. Pronounced gri-SIGH, it's from the French word *gris*, meaning "gray." (Note that grisaille can also be used to refer to monochrome underpainting in general.)

You can think of grisaille as a way of drawing with paint, and you may even want to use a rather dry brush, lightly scumbling your image onto the canvas. Doing an underpainting this way can nicely bridge the gap between drawing and painting, and provide a level of comfort for more reticent beginning acrylic painters. The grisaille approach can be used for figure painting (see the example above) and is also well suited to still life, as well as landscape and other spatial-illusion work.

"NO HALFTONE" UNDERPAINTING

Though less common, there is yet one more method of single-color underpainting that can be useful as an exercise for sharpening your sensitivity to spatial relationships within a composition. My name for this is no halftone underpainting—in other words, underpainting that uses just black paint on a white ground (or white paint on a black ground) with no shades of gray. I know that the old saying "Nothing is black and white" is true for most learning and thinking, but suspend your doubt and come along with me.

Get your viewfinder out and find something to look at—something close and simple. When you have framed the composition in your viewfinder, squint your eyes until all you see are the big forms in your view. Study this little composition to see if you can reduce it to just a simple grouping of dark and light shapes. Now try to sketch it as simply a black and white composition—ignoring all the halftones, which actually define what the objects are. It's easy to do this sort of thing with a camera and some photo-editing software, as shown in the illustration on page 126, but you should try it using just your viewfinder and painting with black paint on a white ground (or vice versa).

(Continued on page 126)

Even if you don't do a monochrome underpainting before adding color to a canvas, it's likely that you'll still be doing some underpainting, perhaps quite a lot, while working on a picture. I call this process "color underpainting," because it involves building up the surface of a painting with successive layers of paint, refining and improving the color as you do so. To see how it's done, let's return to my still life of a cinnamon roll and coffee that I introduced in chapter 6. Here are the steps I went through to create this work.

After setting out my breakfast of a cinnamon roll and coffee, I realized that I might have just set up a still life. I got my camera. When I uploaded the picture I had taken and looked at it on my computer, I saw that the photo contained several bits that I would be happier without. But artists are allowed artistic license, so I was comfortable with what I did next. With the aid of Photoshop, I removed a few distracting things from the image and cropped it so that its dimensions were of the same proportion as that of the canvas I'd be working on.

Having cropped the photo to a 2:3 height-to-width ratio, I now divided the image into six equal squares, as shown. Transferring the image to the canvas using these squares seemed much less intimidating than trying to transfer the whole image onto the canvas all at once. The canvas measured 16 x 24 inches, so I blew up each of the six squares to 8 x 8 inches and printed them out.

Now I divided the primed canvas into six 8-inch square units. Slipping a sheet of graphite transfer paper underneath each printed square, I traced the image on the square onto the corresponding square on the canvas.

I was now ready to begin painting, working through the top three squares without worrying too much about clarity or precision but rather going for shape and basic color. This is what I mean by color underpainting. It has much in common with monochrome underpainting but has the extra benefit of allowing you to roughly approximate the color that will eventually be there. In color underpainting, you can even use a "false color"—one that is correct in value but not exactly the right color—as a placeholder until you can get back to that passage with the proper color. I have seen people agonize over getting a color just right, thereby losing focus and momentum and eventually becoming discouraged and quitting. Remember, it's just paint. You can always change it.

I always make it a practice to work through each square at least three times, attempting to be a bit more precise each time. Once I was more or less finished with the top three squares, however, I noticed that the lower three squares would be primarily dark and dominated by black. So even though I had already drawn the lower section, I decided to gesso over the lower section using black gesso. The lesson here is that you can change

a painting at any point, and there is nothing too good to be changed. After applying the black gesso to the lower area, I redrew the images on the three lower squares, this time using a white water-soluble pencil, combined with white transfer paper.

As I worked across the lower area of the painting, I first rendered the shapes loosely, being much more involved with color and the "feel" of the area rather than trying to produce a polished product at this point. Closing in on the last stages of a painting is quite exciting. Everything comes to a finish, and at this point, I try to slow down. Too many times, I have found that hurrying the end of a painting can spoil the whole thing.

Now was the time for contemplation. I set aside the six divided fragments of the image and allowed myself to think of the whole painting more than I had done up to that point. I checked for consistency of value, color intensity, and even paint quality. Though it may have been possible to finish this painting in one session, I spent several days working on it in short spurts. That way I could recognize some inconsistencies that had crept in. At this point in a project, I may also ask myself if I can add something to the work or remove something from it for the sake of the finished statement. The irony is that even though I'm a hyperrealist painter, my paintings don't really look exactly like the photos or objects on which they're based.

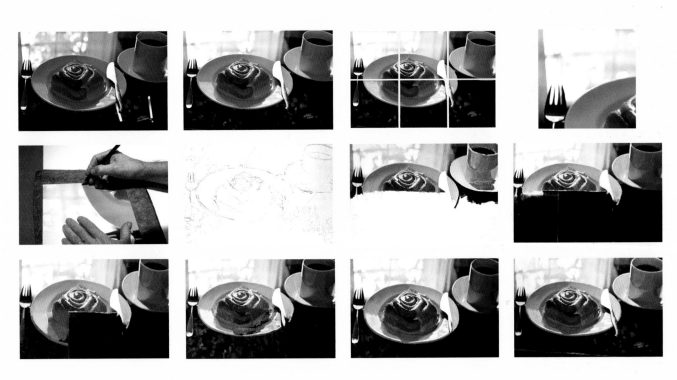

Right: When doing a "no halftone" under-painting, you reduce everything within the frame to black and white shapes, as in the altered image right, which is based on the source photo left. The illustration on the right was made using a common setting found on most digital cameras.

I often do two-value underpainting, because it is easier to work light over dark in building color passages. The iPhone photo at left is an in-progress shot of a painting for which I first made general divisions of white and black for areas that would be predominantly dark or predominantly light. For comparison, I'm also including the finished work below the snapshot.

USING A TONED GROUND

When doing an underpainting, it may be useful to first tone the entire canvas in a middle value—a value midway between the darkest dark and the white of the primed canvas. Apply a thin coat of paint, and allow it to dry until it is dry to the touch before drawing the shapes that will become the basis of the painting. The choice of a drawing tool for a toned canvas is pretty much dictated by the value of the toned surface. I often use a Stabilo All colored marking pencil. These pencils are water-soluble and will mark almost any surface while washing off easily. I usually use a white pencil on toned canvas, but a blue or black one might work better, depending on the tone.

You'll remember that I've recommended finding the lightest lights and the darkest darks and working toward the mid-tones from there. Painting the light-est areas in white is the most foolproof approach, but if you're using one of the slow-drying paints, there's an alternative way of establishing the light-est areas: Using just a water-dampened cloth, you can lift off a toning layer of Golden OPEN paint, exposing the white pre-primed canvas beneath for up to twenty-four hours after the toning coat has been applied. Or, if the slow-drying paint is dry to the touch, you can dampen a cloth with Atelier's Unlocking Formula (see page 9) and use it to remove almost all of the toning coat from the areas that will be lightest. (This will work even if the slow-drying paint used for the toning coat is not an Atelier product, though perhaps not quite as well.)

Above: This snapshot, taken in my studio with my iPhone, shows the black-and-white underpainting for my painting *Wet and Bright*. (The completed painting appears below.)

Having established the lightest lights, you now begin to bring the darks into the composition. This is most easily done if you have a thumbnail value sketch to help you determine where the lights and darks will go. Using a toned canvas as the basis for an underpainting saves time, because you won't have to fill in the middle range of value. When you complete the underpainting, most of the painting's really tough stuff will be done; all that awaits you is the fun of putting on all the color.

Many painters use a toned ground even when they are not doing a complete underpainting. There is something intimidating about facing an expanse of clean white canvas, even if that expanse measures only 8 x 10 inches, so toning the canvas before beginning to paint can have psychological value. Using toned canvas can also provide an economic benefit. It takes less paint to cover a ground painted in a middle gray than a white primed canvas. White is hard to cover, requiring more coats of paint to create an opaque effect. You may want to try this out, possibly using one of the gray gessoes that are now available.

USING PHOTOGRAPHS

If you make paintings based on photographs, you're in good company. The impressionists wanted to capture the impression of a moment of light illuminating the world, and one impressionist painter, Edgar Degas, sometimes used a camera to freeze time and frame the components of possible paintings. The images below show one of Degas's photographs and the use he made of it in developing a painting.

Nowadays, the ubiquitous cell phone camera has provided all of us with a means to frame and capture the random visual surprise of any moment, anywhere. Photo-editing software like Photoshop has given us myriad ways of further manipulating the frozen moment, firing our imaginations as we alter value, color, size, proportion, and many other aspects of the photographic images we take.

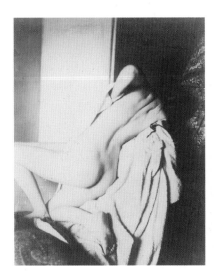
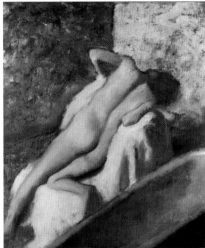

Painters have been using reference photos since the nineteenth century, as proved by this photograph by Edgar Degas and the painting he based on it.

Left: Edgar Degas, *untitled photograph*, 1896, gelatin silver print. J. Paul Getty Museum, Los Angeles.

Right: Edgar Degas, *After the Bath, Woman Drying Herself*, 1896, pastel on paper, Dimensions unknown. Private collection, Paris; photo by Erich Lessing/ Art Resource, New York.

Once you've taken some pictures and chosen one that you'd like to use as the basis for a painting, you face the challenge of transferring the image to your canvas. You could simply draw the image freehand on the canvas, referring to the photo as you do so. But for a hyperrealist painter, that method isn't great, because it's so difficult (if not impossible) to make a freehand drawing that transfers all the elements of a photographic image in a perfectly accurate, detailed way. I usually use one of the gridding techniques that artists have developed over the centuries. These techniques aren't useful only to hyperrealist painters; realist artists who work in a more painterly style but who want to ensure that their work accurately conveys the shapes, proportions, and values of a reference image can also benefit from them.

Let's take a look at one of these gridding techniques with a portrait. Almost everyone who tries to paint would like to paint people, but most people are intimidated by the prospect of having to draw a face so that it really captures someone's likeness—especially when working from a live model who keeps shifting position (even if only slightly) and who sits in an environment where the light is constantly changing. Using a photograph solves these problems, but you're still faced with the challenge of transferring that image to the canvas.

I usually introduce the following exercise in my classes to help my students confront and manage their fear before it gets too big. This diagonal-grid method requires few tools and no real math or geometry skills. In fact, you can do it without measuring at all. To do the exercise, you'll need a photo of a person's face, a pencil, a canvas, and a ruler or some other straightedge that is as long as, or longer than, the distance between diagonally opposite corners of the canvas.

Before beginning, find a photo of a face that is as unlike your own as possible. I would suggest choosing a picture of a person of a different gender, age, ethnicity, and/or skin color. Make sure the image is of someone you have never seen before. The purpose of choosing a very different sort of face is to "remove the familiar"—to prevent you from falling into the trap of prior assumptions about the way people look.

1) Work with two pieces of paper. One must be fairly long—at least long enough that when folding it you make a straight-edge that will reach from one corner of the canvas to the diagonally opposite corner. The second piece of paper can be much smaller: an 8½ x 11 piece of copy paper will be just fine. Also, make sure that the second piece has corners that are right angles—a standard symmetrical shape.

Line your piece up with the opposite corners of the canvas, and draw a straight line between them. Then draw another straight line between the other two opposite corners.

2) At the point where the two diagonal lines intersect, use the right angle of the small piece of paper to determine a perpendicular. Then put a tick mark at the outside edge of the canvas, and draw the perpendicular line to the center. Do this on each side of the canvas, creating four rectangles that are overlapped by the crossed diagonal lines.

3) Now, draw diagonal lines between the opposite corners of the smaller rectangles you've created.

4) After gridding the canvas, place your reference photo on the canvas at one corner, lining up its bottom and side with the edges of the canvas, as shown. Line up your straightedge with the diagonal of the grid, and draw this line over the photo. The point where the diagonal crosses the top edge of the photo establishes where the photo should be cropped so that its proportions are the same as those of the canvas.

5) The way any grid system works is by re-creating the same shapes that are on a small or large gridded surface on an identically proportioned surface that is larger or smaller than the original source. The next step is to repeat the same gridding process on the photo that you have used on your canvas. Remember that in the last part of step 4 you established the crop point and the proportions for the photo.

6) It helps to position the reference photo and the canvas sideways or upside down to help you forget, for now, that you are drawing a face. You want to overcome your mind's tendency to generalize about what eyes, noses, and ears are supposed to look like, which can send a terribly inaccurate and confused message to your hand. By thinking of the parts of a face simply as lines, arcs, and other small pieces, you'll produce a much truer likeness. Gridding the painting surface and the photo reference in exactly the same proportions lets you redraw the image on the canvas's surface one small module at a time. As you draw, concentrate on the shapes you see in each module, forgetting about their relation to the whole picture.

After you have transferred this close approximation of the reference photo to the painting surface, there are several ways to proceed. You could do an underpainting in umber, or a black-and-white grisaille, or a color underpainting as described in the sidebar on pages 124-125.

The gridded reference photo (top) guided me as I made the drawing for my painting *Stowe Slope* (bottom).

Above, bottom: James Van Patten, *Stowe Slope*, 2009, acrylic on linen, 48 x 64 inches (122 x 162.5 cm). Private collection, England.

ALTERNATE GRIDDING METHODS

The gridding method described on pages 128–129 is probably the least difficult, because there's no need to do any measuring or arithmetic. But there are methods of creating a grid that involve measuring an image, deciding on the size and number of squares to impose over that image, and then gridding the painting surface in a corresponding way. The images below show such a grid superimposed over the reference photo I used for my painting *Stowe Slope*, as well as the finished painting. If you can use Photoshop or some other photo-editing software, the process of gridding images is much easier. You do need to make sure that the source photo and the surface on which you're going to paint are of the same proportion and, of course, that each grid has the same number of units.

PROJECTING AN IMAGE

Projecting an image onto your painting surface might seem like a relatively new art method. In all probability, it isn't. A number of artists and writers have argued that projection was used hundreds of years ago by artists like Johannes Vermeer. We do know that Vermeer had a camera obscura—a box-like device that allows an image to be projected on the back wall of a chamber opposite a pinhole in the front of the chamber. The projected image is an accurate replication of the visual reality directly in front of the pinhole (though upside down), and the extreme clarity and accuracy of Vermeer's pictures may be due to his use of the device. Later, during the nineteenth century, the American painter Thomas Eakins projected photographs on glass slides onto his large canvases.

Projecting an image is no more "cheating" than is using a grid to scale an image up or down in order to transfer it to a different surface. Seeing something and wanting to communicate that vision is what art is all about—along with the many choices an artist makes about color, light, texture, value, and so on. So the initial drawing on the canvas is almost negligible. (I am not trying to minimize the importance of drawing or the benefits an artist gains by honing perception through this discipline.)

If you want to work with a projected image, first settle on a subject for the composition. Decide if you are going to underpaint or just work from area to area, with your drawing being your primary guide when the projector is off. And decide, too, whether you'll use the projector in the beginning phase only (with a hard copy of the photo as a reference after the initial projection) or keep on projecting at intervals throughout the process.

First, of course, you'll trace the projected photo onto the painting surface. But as you paint, you will do all the same things you'd do if the subject were immediately in front of you—the value shifts, color adjustments, and so on. The difference is that the light will not shift, the model will not move, and you can't be forced to stop painting because the weather changes! In other words, you can manage the whole process better. When you quit painting for the day, you are able to start again the next day with the exact same visual experience. Plus, you can check your accuracy by re-projecting whenever you choose. My friend the English painter John Salt does this rather obsessively, as you can see from the photo at right. The superrealistic results he achieves through this exacting method are seen in his painting *White Chevy Red Trailer* (above).

I confess that I've made only one painting based on a projected image: *Study in Orange and Blue and Other Colors* (on page 132). My reason is that I don't really like always being able to see what the whole painting will look like. I prefer working on one little square at a time, because I love surprises.

The photographic accuracy John Salt achieves through the use of a projector is demonstrated by this work.

John Salt, *White Chevy Red Trailer*, 1975, acrylic on canvas, 44 x 65 inches (111.75 x 165 cm). Courtesy of the artist.

English artist John Salt is one of the photo-realist painters who uses a projector to transfer photographic images. Here, he's using a magnifying glass to make sure he gets every detail right.

James Van Patten, *Study in Orange and
Blue and Other Colors*, 1999, acrylic on
linen, 48 x 48 inches (122 x 122 cm).
Private collection.

OVERPAINTING

I use the term *overpainting* to mean painting on top of a passage that will
remain in the finished work—for example, painting a tree's branches over a care-
fully rendered sky full of ornate clouds. This can cause more than a little anxiety
for a beginning acrylic painter, though the fast-drying properties of ordinary
acrylic paint can be advantageous here, since if there is an inadvertency you
can quickly correct it by painting over it.

Overpainting is part of the process of refining or adjusting an image. In devel-
oping my breakfast still life on pages 124–125, I did quite a lot of overpainting.
It is my practice to paint somewhat sloppily during the first pass through of
a section of a painting. When that area has become more resolved and the
colors, shapes, and general distribution of darks and lights are beginning to
look okay, I go over the whole area again. I do this whether I am working on
the whole painting at once or on just part of the painting, as when I divided the
painting surface into 8 x 8-inch squares.

DARK OVER LIGHT

You might think that painting a dark color over a light one would not be particularly difficult, but it usually is. That's because the darker the color is, the more likely you are to run into opacity problems. For example, most umbers (browns), quinacridone magenta, and ultramarine blue—all dark colors—aren't especially opaque. An opacity rating appears on most tubes of acrylic paint. This rating can be useful when working a color into a white or light ground. It is seldom a good idea to expect complete, opaque coverage with just one coat, so plan on laying down two or more coats when overpainting, especially if you use a wet palette. (If you use a dry palette, the paint will have a somewhat heavier body and may cover a bit better.)

Sometimes, when the paint really seems not to cover well, the problem may be that you are actually pulling a previous layer of paint off the surface. This happens when a passage is overly damp and moisture has worked its way under the paint that is beginning to dry. If you keep painting, you'll just make more of a mess, so quit and allow that area to become dry to the touch, only then returning to that passage with a thin coat of color, followed by successive coats until you achieve the level of coverage you want.

A couple of things can make painting over a white or a light color easier. Because fluid acrylics have a higher load of pigment, they provide somewhat better coverage; the drawback is that the original formula may leave some brush marks or ridges if not used in conjunction with a flow enhancer (see page 15). A new Golden fluid acrylic, which replaces the company's airbrush line, has superior self-leveling properties but unfortunately is much more transparent than their original formula (which remains available). There are also some lines of high-pigment-load colors, including the one made by Golden, that can improve opacity.

LIGHT OVER DARK

I prefer working into a dark or even black surface. I guess I've just spent too many years feeling intimidated by those vast expanses of empty white canvas. My painting *Stowe Slope* (page 64) was painted on linen canvas primed with black gesso, as was *Down Back* (page 134). Black gesso, which aside from its color has all the same properties as white gesso, is now available almost universally at good art supplies stores.

For *Stowe Slope*, I primed the linen surface with three or four coats of gesso that I had thinned with water to about the consistency of pancake batter and brushed on with a wide brush. Between coats, I sanded the surface until it was quite smooth. Although most of the colors I used were fairly opaque, I knew from the start that I would have to use multiple coats of paint to cover this dark surface. So, when beginning, I mixed sufficient quantities in containers, which I

The opacity rating on the back of the paint tube will give you an idea of how well a particular color will cover other colors.

then used to coat most of the black-gessoed canvas. The green coat I applied to most of the painting–you can see it along the lower part of the painting in progress shown at right–is called a local color. The use of a local color in my work provides a base that is close to the average, or common, color of a passage in the painting. Because of the color shift from light to dark that occurs with most acrylic paint, having this local color established, both in a dry state on the canvas and in a wet state in a container, lets me know where to start when altering the value and intensity of the passage in progress.

The amazing quality of light that some painters are able to achieve does not usually have to do with the way the painter handles light colors but rather with the richness of the deep values and mid-tones. I still want to make a painting with light so intense that it will hurt your eyes–an effect I think I came close to in my painting *Wet and Bright* (below). For this reason, I usually work with a selection of very dark colors, usually using six different blacks–green black, carbon black, blue black, Mars black, red black, and brown black. Combining these blacks produces very subtle shifts between warm and cold, and when you present the viewer with these in the right context, they sharpen the sense of light when the eye moves to a brighter area. Giving just a little bit of bright at a time enhances the sense of illumination.

Above: This shot of my painting *Stowe Slope* in progress shows the "local color" (the wide band of yellow green) that I applied to the black gesso beneath.

Left: The intensity of light in my painting has more to do with the darkness and richness of the blacks than with the qualities of the lighter colors.

James Van Patten, *Wet and Bright*, 2012, acrylic on linen, 32 x 32 inches (81.25 x 81.25 cm). Collection of the artist.

Opposite: My painting *Down Back* is one of several I've done on linen canvas primed with black gesso.

James Van Patten, *Down Back*, 1998, acrylic on linen, 48 x 72 inches (122 x 183 cm). Private collection.

PAINTING HARD EDGES

During the 1960s and 1970s, a large number of painters broke away from the riotous color and exuberant brushwork of the abstract expressionists. Some chose to juxtapose colors very closely—sometimes so closely that the divisions between colors were hardly visible. The image on page 138 shows a painting in this style by Gene Davis. For their hard-edged works, nearly all these painters used acrylic paint.

It's easy to produce a hard edge using masking tape and following these steps.

1) Lay down the tape in a configuration that you have already drawn (the edge of a square, a stripe, or some other shape). Now burnish the edge of the tape with something hard and blunt, like a rounded part of a spoon or maybe just the flat part of your fingernail.

Then, having secured the bond as tightly as possibly by hand, paint a coat of matte or satin medium over this edge of the tape. You're doing this because masking tape is actually a kind of crepe paper; no matter how hard you press it down, fluid may find its way under the edge along the channel of one of the tiny crepe-like ridges. But if the medium crawls under the edge of the tape, it won't matter, since it will be invisible when dry. Let it dry until it is dry to the touch, with no tackiness at all. Next, paint the area that you want to have this straight edge.

2) Before you remove the tape, check for coverage, opacity, hue, value, and intensity. After you've made sure that the painted area is exactly as you want it, allow it to dry completely. A hair dryer may come in handy when working with hard-edge shapes, to make layers of paint and sealing medium dry faster. Generally, it's okay to force-dry acrylic paint if the paint is fairly thin. When force-drying with a hair dryer, I always use the following rule of thumb: if you can see brush ridges or any other indication of fairly thick paint before you start force drying, allow more time for the paint to dry completely. When the surface is not only touch-dry but also feels cool to the touch (no longer warm from the hair dryer), remove the tape very slowly.

PAINTING LINES

Painting a line is just about the same as painting any hard edge, but it involves the use of three pieces of tape. Let's say you want to paint a line that's ¼-inch wide. First, lay down a strip of ¼-inch masking tape where you want the line to be. Then, lay down a wider strip of masking tape on either side of the ¼-inch tape. Once those strips are in place, remove the ¼-inch strip, which has been serving as a spacer. Burnish the edges of the wider strips, and then brush medium onto the space where the line will be, waiting for it to dry before laying down the color. When the color is dry, remove the two wide strips of tape.

1)

2)

ARTFUL TIP Collage

Collage predates acrylic painting by decades. Although people began collaging together photographs in the nineteenth century, the use of collage in fine art is generally attributed to Pablo Picasso and Georges Braque during their synthetic cubist phase, when they started to include scraps from daily life—pieces of newspaper and other printed materials, for example—in their paintings. Soon, other artists, like the Russian painter Kazimir Malevich (see the image at right) did the same. By using pieces of paper one might not expect to see in a work of art, they created interesting representational and abstract effects.

Besides being fun, collage can also help rescue a painting that isn't going well: believe me, it is sometimes much easier to put a piece of paper over a troublesome passage than to fight with it to make it look better! Adding a collaged element, however, may force you to make a commitment to proceed further with collage rather than solving the problem with paint.

Acrylic painters have a distinct advantage over earlier painters. Incorporating collaged elements into their work is easy, because acrylic mediums are perfect adhesives for paper and similar materials. Many collagists use matte medium—or matte gel if they're attaching heavier pieces. Unlike other pastes, acrylic mediums create a permanent bond between the paper and the artwork's surface, and they're invisible (or very nearly so) when they dry.

I sometimes do collages for fun or for demonstrations, using whatever materials are readily available. When making a collage, place the pieces you wish to use on your working surface, moving them around until you've decided on a composition. Then brush acrylic medium onto the back of each piece and onto the area of the surface where you'll be placing it. You may at any time also include paint in the process.

Kazimir Malevich's *Soldier of the First Division* is an example of cubist collage.

Kazimir Malevich, *Soldier of the First Division*, 1914, oil and collage on canvas, approx. 21 x 17½ inches (54 x 45 cm). Museum of Modern Art, New York.

I wanted to do a collage demonstration for one of my classes, so I made this piece from scraps found in the studio during the minutes before class began.

James Van Patten, *You Can Get*, 1998, collage on canvas, acrylic medium and acrylic paint, 10 x 8 inches (25.4 x 20.5 cm). Collection of the artist.

Using a Bridge

There is another way to create hard-edged lines with acrylics. It involves using an illustrator's tool known as a bridge, which steadies your hand above the painting's surface. Bridges are available from good art supplies vendors. But be forewarned: this method requires practice.

To make a straight line with a bridge, make note of the angle of the brush all the way down the shaft to the tip, maintaining that same angle as you allow your fingers to ride along the edge of the bridge. The angle of the brush must not change or your line will become wavy. Move your hand along the bridge in a smooth left-to-right motion (right to left if you're left-handed), taking care that the paint on your brush is discharged evenly. Then recharge the brush and start over. One drawback to this method is that it works best when the painted surface is flat, not vertical (as most painters prefer to work). It took me a few days to become comfortable with this tool, and when I use it now, I always do several practice runs on something other than the painting on which I'm working.

The new acrylic markers introduced by Liquitex and other manufacturers, which I mentioned in chapter 1, give painters yet another way of creating lines and other hard edges. They are available in a variety of widths.

Here, I'm creating a straight line of paint using a bridge.

BLENDING

Blending is a way of using paint to suggest transition or to create the illusion of volume. It's needed when painting skies, water, apples, spheres, shadows, cylinders—all sorts of things that require paint to remain workable long enough to traverse values from dark to light or vice versa. In the past, acrylic paint was considered notoriously poor for blending because of its fast-drying property. I and many other acrylic painters devised strategies for overcoming this problem. My friend John Salt, for example, used an airbrush in the painting *White Chevy Red Trailer* that appears on page 131. Note all the passages

in the painting—on the hood and fenders of the car, for example—where a tone moves from bright to dull or from light to dark. Achieving such subtle shifts can drive you crazy. With an airbrush, however, the application of one mist of paint over an area provides just such a blend.

You don't need to use an airbrush, though, to successfully blend today's acrylic paints. In years past, slow-drying oil paints were preferred for blending because they remain workable for such a long time. But Golden's OPEN line and the other slow-drying acrylics now on the market closely approach the blending properties of oils. And the invention of the wet palette, which makes mixed colors usable for almost endless periods, has also been a game changer. For large blended areas, where the amount of paint a palette can hold simply isn't adequate, I premix large amounts of the colors I intend to use. And I mix up some of my Van Patten's Solution (page 22), putting it in a large spray bottle adjusted to as fine a spray as possible. Then, using fan brushes, I begin the process of building a blended area, which can take a long time to complete. The sidebar "Blending a Large Area" on pages 140-141 details the process I went through when painting a large blended area.

GLAZING

The term *glazing* conjures up images of gleaming Flemish Renaissance paintings, their jewel-like surfaces achieved by layering many coats of lightly colored, varnish-rich paint. Actually, a glaze is any thin coat of paint, of any kind, that is painted over an existing passage and that changes the character of that area. This change might be one of value, color, intensity, or even texture. Here, though, I'm going to focus on glazes made with resin-rich, pigment-carrying fluids. In the picture opposite, I used many thin layers of very thin, glazing liquid-rich paint, often glazing lighter values over darker values, to create the illusion of steamy morning mist rising from the lake near my home.

Most acrylic mediums can be used as transparent vehicles for paint, and glazes made by mixing mediums and small amounts of paint can produce effects much like those of the historical glaze paintings. The beauty of acrylic glazes is that they do not require days to dry between coats. The two mediums that I have used—and highly recommend—are Golden's Acrylic Glazing Liquid, which is made in both gloss and satin, and Winsor & Newton's Artists' Acrylic Glazing Medium. Both fluids appear milky in the bottle, but the milky quality virtually disappears when the fluid is mixed with pigment or applied to the painting's surface. (Winsor & Newton claims that there is no color shift with its product.) These products are especially good if the glazes you're building also involve some blending, because they extend drying time to 30 or 45 minutes, easily allowing you to blend as you lay down the glazes.

(Continued on page 142)

I followed these steps when working on my painting *Study in Blue with Red, Green, and Other Colors.*

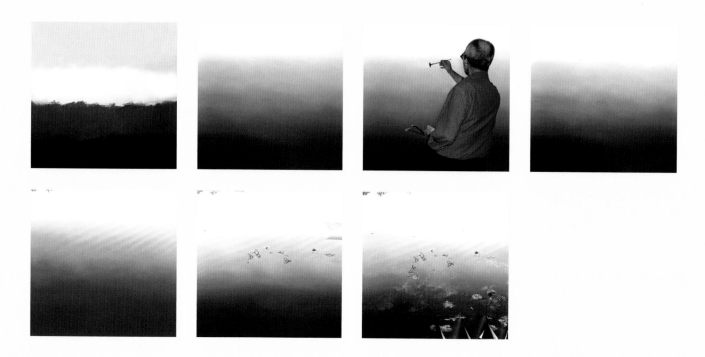

1) At the beginning of the work, I reduce everything to its simplest terms. At the top, the image will have a neutral lightness that's not pure white but like the tone of clouds around the horizon on a warm autumn day. The values will darken as your eye travels down the painting, so I paint the canvas in four bands approximating the basic colors and values in each position. Getting rid of the intimidating white canvas is the most important thing at this stage.

2) In the second stage, I begin to blend the color, making the transition from dark to light more gradual. Here, I introduce a thin white coat at the top, allowing just a hint of the warmth of the gray undercoat to show through. In the lower areas, I introduce several mid-blues, likewise coating thinly the darkness of the undercoats. While doing this, I'm frequently misting the areas being worked, initially rather heavily with Van Patten's Solution and later, less heavily, with plain water. The blending itself is accomplished with fan brushes—hog bristle or synthetic hog bristle—of several broad widths. As a rule, I work with several brushes at once, switching back and forth between brushes depending on the depth, intensity, and value of color I'm using.

3) For this step, I use several brushes. Although you can probably see little difference between the painting at this stage and in the previous and following images, I include them all to make the point that it's by constantly painting in and painting over that you eventually reach the quality you want.

4) Notice the subtle blue-green and blue-violet tint at the top edge of the blue tonal blend. This subtlety was a little tricky, with many inadvertencies requiring do-overs until I thought I could live with the color shift.

And here is the finished work.

James Van Patten, *Study in Blue with Red, Green, and Other Colors*, 2009, acrylic on linen, 48 x 48 inches (122 x 122 cm). Courtesy of Plus One Gallery, London.

5) At this point, I stop being an abstract painter and begin to bring in visual cues that suggest water and landscape. The soft blending of the diagonal wave representations was done with small fan brushes. Fan brushes are especially useful, because they have a wide spread but hold only small amounts of paint. The extremities of the fan also pick up a bit of paint, mixing it with the low paint charge of the fan and achieving a blend.

Also in this phase of the painting, I begin to include other hints of land-scape. You can see a reflection of bare tree branches in the upper left of the painting. Compositionally, this corner is the natural entry point of the eye, so the viewer coming upon the painting instantly understands that the image is of a body of water near a shoreline and thus is not too surprised to discover the illusion of shallow water in the lower right of the painting.

6) Now I begin to develop the detail. I usually divide my reference photo into 8-inch-square modules, printing them out and taping them to the canvas as I work.

7) The process of painting and checking, painting and checking marches on one module at a time. Artist Chuck Close has extoled the advantage of working in such a methodical way, one square at a time, saying that it is like knitting: you can set it down and pick it up at any time without wondering what you were doing when you left off.

The subtlety of the atmospheric effects in my painting *Shadow and Reflection* results from countless glazes.

James Van Patten, *Shadow and Reflection*, 1993, acrylic on linen, 48 x 72 inches (122 x 183 cm). Private collection.

It's not really glazing per se, but there's also another way that a glazing medium can be useful in your painting process. Several times during a painting session, I charge a fan brush with one of these glazing products—usually one that will produce a gloss finish—and coat the area that I have worked on most recently. This lets me see what that area will look like when the painting is given its final varnish. The glazing fluid "freshens" the paint (already dry to the touch), bringing it to a uniform level of color and intensity. Although the paint is not wet, the surface is, with a smooth, damp, not-quite-tacky feel under the brush. It is possible to add color or paint out detail, almost like you're working into wet paint. This is yet one more way that the acrylic painter can control the process, unbothered by paint drying too fast.

IMPASTO PAINTING

The impasto technique involves heavily building up paint on a surface using a brush or, more commonly, a painting knife—or one of the new paint-moving tools discussed in chapter 1. Many painters, both abstract artists and painterly realists, want the mark of the artist's hand to show clearly in their work, and there's no more exciting or dramatic way of doing this than through impasto. Larry Poons's *The Flying Blue Cat* (below) gives you some idea of the effects a contemporary impasto painter can achieve, though to truly appreciate a textured work like this, you must see it up close, in person.

Impasto technique need not be used alone. Interesting visual/textural effects can result when impasto is combined with other painting methods within a single work. When I was in graduate school, I was fascinated by surface and by the three kinds of space that a painter is constantly considering, whether consciously or not: (1) the illusion of three-dimensional space within the painting, (2) the actual space occupied by the painting's ground (e.g., a stretched canvas), and (3) the space in front of the canvas, or the "room space." Those fascinations gave birth to my monochromatic work *Silver-Scape* (page 146), which incorporates several close values of gray—some cool, some warm—as well as a metallic paint that made the canvas buckle and reflected people and objects in the room. My addition of an impasto passage made with a different silver-colored paint emphasized the tension between all three types of space.

(Continued on page 147)

Larry Poons uses impasto technique to create a highly textured effect across the entire surface of a painting.

Larry Poons, *The Flying Blue Cat*, 2011, acrylic on canvas, 73½ x 105½ inches (186.5 x 268 cm). Courtesy of the artist.

To paint en plein air means to paint "in the open air," and it's a phrase established by the French because it was the French impressionists of the nineteenth century who first took painting out of doors. Plein air painting is not a technique per se but rather a way to practice seeing and being in the moment—and it's now such a common practice that it's hard to believe that when the impressionists began to paint outside, the art world went up in arms, thinking the whole idea not only impractical but also foolish.

When painting outside, one must paint with greater speed than in the studio. There's not much time to contemplate or plan. Many impressionists returned to the same places repeatedly, observing and recording the changes that happen through the seasons. Gaining an understanding of the forms of a given landscape freed them to pay attention to the moment-to-moment changes of light and shade that had never concerned painters previously.

Plein air painting doesn't lend itself to making monumental paintings; the plein air painter who goes outside to work usually intends to finish the work in one session and must therefore work on a smaller scale. But it's just this small, doable quality that hooks many plein air artists, like California landscape painter Marcia Burtt, whose painting *Ebb Tide, Otter Point* appears opposite.

It's possible to take oil paints outside (after all, that's what the impressionists did), but there are advantages to working with acrylics, which don't involve any smelly, volatile fluids and don't require you to transport a wet, sticky canvas home at the end of a session. And many people who have worked outside with watercolors have found the addition of acrylic paint to their palette to be extremely useful: for instance, if a sudden act of nature, like raindrops falling on your picture, damages a watercolor, you can do some on-the-spot repair with acrylic white to restore the white of the paper. (It follows that those same acts of nature can't seriously threaten an acrylic painting.)

Although I think painting outdoors is a wonderful idea, I must confess that I myself don't do it—simply because you can't get a 4-x-5-foot painting done in an afternoon. So I take photos instead.

If the idea of working outside intrigues you, I would recommend using the newer slow-drying paint by Golden, because it stays in place on a dry palette held vertically. I would also recommend you limit the weight of what you're carrying, so work small and on the lightest surface you can find that you like. (Some of the new synthetic papers have almost no weight at all.) Take only what you need—there will always be another day.

Marcia Burtt does most of her work outdoors, capturing scenes from California's natural environment, as in this coastal view.

Marcia Burtt, *Ebb Tide, Otter Point*, 2011, acrylic on canvas, 18 x 30 inches (45.5 x 76 cm). Courtesy of the artist.

Today's acrylic painters can select from a truly enormous array of products for creating impasto effects. Ordinary acrylic paints aren't ideal for impasto, because they dry too quickly and if applied too thickly can actually pull off the canvas rather than bind to its surface. Manufacturers of acrylic paints and additives, however, have solved these problems by making gels that enhance the body of the paint and that make it easier to move the paint around and to form the kinds of textures that impasto painters desire. The variety of these gels is staggering (see pages 27–28), and it may take a lot of research and experimentation to really understand what you can do with them. It's worth the effort, though. There are even some slow-drying gels now appearing on the market. And beyond gels, there's also a wide variety of modeling pastes that will accept pigment.

There's a problem with these gels and pastes, however. All these additives have the unfortunate effect of dulling and weakening the color, and also of significantly magnifying the color shift that occurs from wet to dry. There are two solutions to this problem. The first is to use a special paint, made by Golden Artist Colors, called Paste Paint. This is an extremely high viscosity acrylic paint that when applied with a painting knife looks much like encaustic. This is really thick stuff, and its viscosity is affected by temperature, so it won't work well if your studio's too cold. (Another disadvantage is that it's difficult to find and may have to be ordered directly from the manufacturer.)

For the painter who desperately wants to have the feel of ordinary, heavy body paint and the ability to move and blend paint at his or her leisure, there is Golden OPEN and the Winsor & Newton professional line (which has the additional advantage of no color shift). When working in impasto, you need to be able to work for a rather extended period without the danger of suddenly finding that paint that was movable a short time ago can no longer be manipulated. Slower-drying paint is great for this. My experience with Golden OPEN has been quite amazing. The Winsor & Newton paint dries somewhat faster.

LETTING THE PAINTING COMMUNICATE WITH YOU

One morning shortly after breakfast, Paul Cézanne walked into his garden, where he was working on a painting. He put his palette out and, observing his subject, mixed a color with his brush and looked at it, and then went and sat in a chair where he could see his painting. There he sat, looking at his painting, until late afternoon. As he began to lose the light, Cézanne stood up and walked over to his painting and applied the color to one spot on the painting. He then washed his brush and went inside and had dinner with his wife. He'd had a successful day painting.

Opposite: You can combine impasto with other techniques to create textural tensions within a work, as I did with my early painting *Silver-Scape*.

James Van Patten *Silver-Scape*, 1967, 48 x 64 inches (122 x 162.5cm). Collection of the artist.

I have told this story to students dozens of times. I have no idea if it's true, but it sounds true. One of the most important things that happens when painting is the time spent not painting. It is crucial that a painter stop and look at what she or he is doing—or perhaps at what the painting is doing—as often as possible.

Earlier in this book I talked about nuance and inadvertency. While you look at your painting, recall what you have reworked, what you have painted out, and what you have kept that surprised you. Also ask yourself simple questions like, Would I like to live with this painting? Does this painting remind me of a painting I have seen before or that I have painted before? How would I explain the painting to a friend? What color systems are at work in this painting? Could I emphasize a color to create better harmony? What do I like best about the painting? What can I change to make myself more satisfied by the outcome?

And after you have gone through this examination of your work, take a break. Have a cup of coffee or tea, and don't think about the painting for fifteen minutes. This is a must! Take a break! When you come back to your painting with fresh eyes it will look better. One thing I have always wondered about that Cézanne story is, did he ever take a lunch break?

ARTFUL TIP Wet-on-Wet

Watercolorists often use a technique called wet-on-wet, in which color is brought to a wet surface and allowed to diffuse across the wet area, with or without the help of a brush. It's possible to achieve the same sort of diffused effect with acrylic paint. My work *Warped Hill* (right) incorporates several scrap pieces of unstretched watercolor paper of at least two different weights. I had no plan before I started. I thoroughly wet all of the pieces and then applied random amounts of phthalo blue and ultramarine as well as some ocher, maybe some burnt sienna, and who knows what. As I applied the paint, I could see that some interesting things were happening. The paper started to buckle laterally, warping into soft waves, like hills. On some pieces, I added more water to leach out some of the wet paint, and in other areas, I used blotting paper or paper towels to remove paint and water. The whole thing actually developed in front of me as I watched—wet-paint smears, blots, runs. When the pieces of paper were completely dry, I ironed them flat and cut shapes from these random-colored pieces. I then assembled the whole work, butting edges up to edges and splicing the pieces together with a strong adhesive backing. I then matted this jigsaw puzzle of a painting.

For my painting *Warped Hill*, I used a wet-on-wet technique.

James Van Patten, *Warped Hill*, 1971, acrylic on spliced watercolor paper, 10 x 12 inches (2.54 x 30.5 cm).

ARTFUL TIP Using Acrylic Paint as (or with) Watercolor

Technically, acrylic paint is a kind of watercolor—an aqueous (water-based) medium. The big difference between acrylics and what we usually think of as watercolor is the vehicle carrying the pigment. With traditional watercolors, the vehicle is usually gum arabic, a natural substance that, after drying, will return to its wet state when water is reintroduced. But acrylic paint, whose pigment is suspended in a polymer-and-water emulsion, cannot return to a wet state after drying. When acrylic paint dries it is dry—and that's just as true of "open" acrylics as of ordinary acrylics. Still, the extra open time of these newer acrylics does allow artists to treat acrylic paint almost exactly like watercolor for up to an hour or sometimes even longer. And paint can be removed from a canvas with a damp cloth or small watercolor sponge for up to a day after application. If you want to use acrylic paint as watercolor, thin it way down for wet-on-wet technique or to lay down glazes, just as watercolor painters do when building up color.

If you are an experienced watercolorist, you might find that using acrylics as, or along with, watercolors gives you a new degree of freedom. As every water-colorist knows, laying down glazes can be tricky: if your brush is too damp, the layer underneath can be brought back to life—and you end up with mud. I frequently use acrylic paint with watercolor for this very reason. The painting below, for example, combines acrylic and watercolor. The water area depicted in the painting has a tonal gradation going from darker in front to lighter in back. There are a lot of little pieces in this passage that I needed to be able to overpaint without worrying about messing up the tonal progression, so I first airbrushed this passage with thinned acrylic paint, building everything over that in watercolor. Because airbrushed paint is a fine mist, plenty of micro-scopic paper fiber is left exposed to continue absorbing the watercolor.

For my painting *It's Still Too Wet to Walk*, I used both acrylic and watercolor, painting on heavy (300 lb.) watercolor paper.

James Van Patten, *It's Still Too Wet to Walk*, 2012, acrylic and watercolor on paper, 24 x 34 inches (61 x 86.5 cm). Courtesy of Plus One Gallery, London.

08 FINISHING AND PRESENTING A PAINTING

An artist often thinks of the end of the painting process as an abandonment of the work rather than actually finishing. Through presentation, you can mitigate some of this separation anxiety. Whether matting a mixed-media painting like some of the watercolor-and-acrylic pieces shown earlier or framing a large acrylic-on-canvas work, presentation provides a kind of punctuation for the eye, functioning not unlike the capital letter at the beginning of a sentence and the period at the end. It also gives your work over to the viewer to play his or her part in the art process.

Sometimes presentation makes the art. Certainly this was often the case with the pop artists, who took objects from popular culture and with little or no alteration presented those familiar images to the viewer for reconsideration. But presentation can be every bit as important for the realist painter, who also presents a piece of the known world for reconsideration, and for an abstract artist who gives us color, texture, or line unencumbered by the hindrance of recognition. And one important function of presentation is to make the artwork safe for continued viewing long into the future.

The barrier coat is applied prior to the final varnish coat.

PROTECTING THE SURFACE

The last steps in creating an acrylic painting provide appropriate protection for the surface so that the painting won't be seriously damaged in an accident, in a future restoration, or even through ordinary handling. People love to touch things, and their fingers are oily and have all sorts of frightful things on them that can harm paint surfaces. Of course, because acrylic is plastic, acrylic paintings are less susceptible to this ordinary kind of damage than are paintings done in other mediums. Still, it's a good idea to put a protective coat of acrylic film on the painting.

There's a protective step that comes before the final varnishing. The barrier, or isolation, coat is a layer of clear acrylic film—usually a medium or glazing liquid—that functions as a buffer between the pigment layer and the varnish. I have found that using one of the gloss glazing fluids works well for this, because it dries slowly and therefore may be evenly applied with a medium-wide springy-haired fan brush. Be sure to allow a long enough time for this coat to dry completely. This barrier layer bonds with the paint beneath and is not removable. It stands guard, keeping your painting safe, in case some future conservator wants to restore your masterpiece, cleaning off the dirt and grime that have built up over the years and removing the varnish.

Varnish is by definition also a protective coat, but a true varnish can be safely removed from a painting without harming the paint underneath. Some manufacturers of acrylics make fluids that they inaccurately call "varnishes"—an inaccurate label because these finishes may not be removed once applied; however, major manufacturers such as Golden Artist Colors, Winsor & Newton, and Liquitex (and some others) do make true, removable varnishes. Most such varnishes offer the added protective function of shielding against ultraviolet (UV) light. Although acrylic paint is extremely lightfast compared to other kinds of paint, it's still nice to have this extra protection.

Most removable varnishes are soluble only in mineral spirits or one of the turpentine-like solvents. The problem with using them is that they bring you right back to that smelly, toxic stuff that acrylic painters want to avoid. If you don't have a well-ventilated studio or just don't want to use these substances, there are some removable varnishes, available in a variety of finishes (gloss, satin, matte), that are water-soluble when wet and that don't have an unpleasant odor. Read the label, which will tell you if the "varnish" is removable and how it may be removed. These varnishes are removable with household ammonia—which is also pretty smelly, but this is the best I can do! (It is doubtful that you will remove varnish for cleaning or restoring purposes, anyway, but you never know.) I have used both spirit- and water-soluble varnishes, and apart from the odor of the spirit-soluble type, they are both very good. Each brand of varnish is slightly different from the others—for example, Liquitex Soluvar is a bit thinner than Golden—so it is imperative that you read the instructions on the container and follow them carefully.

As mentioned in chapter 1, Golden Artist Colors offers technical support (both telephone and e-mail), enabling you to communicate with a specialist who knows each product and is aware of potential problems and possible fixes. (Consult the Golden website, goldenpaints.com, for information.) I myself have benefited from this expertise. One day, my gallery called to tell me that a painting of mine had developed a waxy haze over a large portion of its surface. They asked me to come and get it and to fix the problem. When I brought it to my studio I found that, sure enough, there was this odd film on my painting, but I couldn't for the life of me figure out what had gone wrong. So I called Golden, got a chemist on the line, and asked if he had ever heard of such a thing happening.

He asked me if I had used a lot of flow enhancer when working on the painting. I told him that I had (it is an ingredient in my Van Patten's Solution; see page 22), and he quickly came up with the answer to the riddle. What had happened was this: I had applied a barrier coat of acrylic glazing liquid to the finished painting, sealing it. Then I'd varnished that surface, but instead of a true varnish, I had used one of the medium-varnishes mentioned above, adding plenty of Van Patten's Solution because I had wanted this "varnish" to flow smoothly and to lengthen its working time. What I didn't know is that flow enhancers tend to gradually migrate. Usually, this happens through the porous back side of the canvas. But I had sealed off that route, and the flow enhancer—a surfactant much like soap—had no place to go except up through the varnish, slowly seeping out of the face of the painting. At the chemist's recommendation, I washed the painting several times with clear water, then applied a new high-resin barrier coat and a final coat of true varnish. I returned the painting to the gallery, and it now lives happily on some collector's wall. Moral of the story: Read directions, and ask for help when you need it.

MATTING, MOUNTING, AND FRAMING UNDER GLASS

Works on paper or thin board are usually matted or mounted and then framed under glass. Let's start with the matting process: The reason to mat a work is to give the viewer's eye some resting time before it's impacted by your visual message—a pause that's equivalent to the quiet moment when the conductor holds the baton in the air before the symphony begins or to the baseball pitcher's windup before he throws the ball.

There is an amazing amount of good art out there that doesn't get noticed because it hasn't been presented properly. There's no excuse for that today, when presentation is easier and less expensive than ever. I used to teach my students how to cut their own mats, but now there are so many good precut mats on the market—mats that cost no more than the materials you'd need to cut your own—that it doesn't make sense to do it yourself.

Two L-shaped pieces of mat board can help you decide whether, and how, to crop a work.

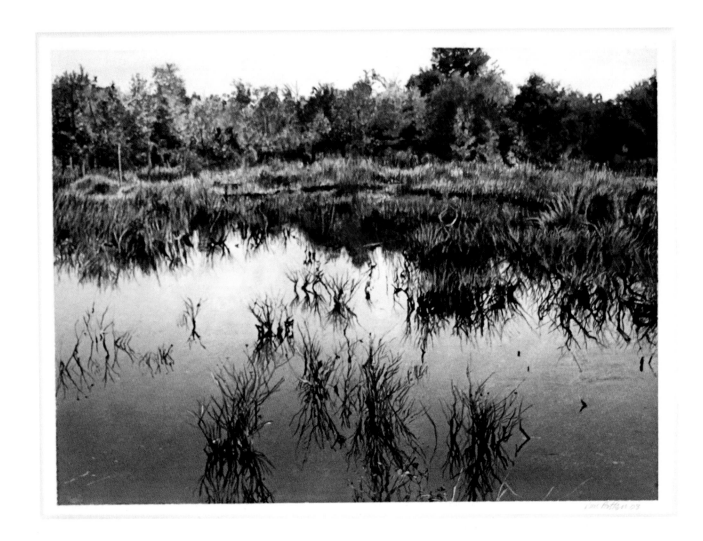

Here's my painting matted and ready
to be framed.

James Van Patten, *Light Fall*, 2003, water-
color and acrylic on paper, 10 x 13 inches
(25.4 x 33 cm). Collection of the artist.

Before you buy a mat, though, you should ask yourself if you should use the
mat to crop the artwork. To decide, you may need a cropping device. It consists
simply of two wide, L-shaped pieces of mat board. You can easily make a crop-
ping device by cutting a large ready-made mat into two L shapes or by buying
a big piece of mat board and then using a metal straightedge and an X-Acto
knife to cut two wide L shapes from it. You then lay these on top of your piece,
adjusting them to create a rectangle or square that looks right, as shown on
page 153. Then you take the measurements of that opening and buy a mat with
the same size window. The variety of precut mats is vast; the only mats I have
had professionally made were for extremely large paintings on paper or board.

You'll need to think about the width of the mat and the color of the mat board. I always recommend using a mat that gives you a lot of space around the work and choosing a neutral color. (White is my all-time favorite, followed closely by white!) Also, if possible, buy mats with cardboard backing so that you can sandwich the art between the mat board and the backing and not attach it to the mat itself. There are some double-thickness precut mats with cut edges that provide an additional white area around the window. These double-thick mats make for a really nice presentation of small works on paper. I use them for small watercolors like *Light Fall* (opposite).

Mounting is an alternative to matting. (In America, mounting means affixing an artwork to a piece of presentation board, which might be a heavy museum board, a piece of mat board, or a hardboard similar to the ones discussed when I covered grounds or surfaces for painting. In Britain, by contrast, mounting means matting.) You may want to dry-mount the work, or you may prefer to use an archival-quality spray adhesive; in either case, ask a staff person in an art supplies shop for product recommendations.

Even if you mount a work, you may still want to mat it. Dropping a mat over the mounted piece can produce a desirable flattening effect. If, however, you will not use a mat, take care not to smear the adhesive agent beyond the edges of the piece. Spray only the back of the work. Then, following the product instructions, press the work down on the mounting until the bond is set. Sometimes it's wise to put some weight—a heavy book, perhaps—on the new mount until the adhesive cures to ensure permanence.

There is one more option for presenting a work on paper—one that I have used occasionally and that a number of my painter colleagues also use. This is simply to leave a large margin of clean white paper around the painted work, making either matting or mounting unnecessary. This is easier said than done, however. Usually, you have to mask the area around the artwork, so that the paper surrounding the work doesn't get dirty while you work. I have used Scotch-brand blue masking tape for this. But that blue color is distracting, so I cover it with another layer of white tape while I'm working. I personally find working on an unmasked board difficult, but some artists have had amazing success with this method.

When you have matted or mounted your work, the next step is to get it framed under glass to protect it from dust, dirty fingers, and (to some extent) UV rays. As with precut mats, there are now many very good ready-made frames available in art supplies stores, often with mats and backing included, so it is possible to present your work under glass with a minimal cash outlay. Also, small frame shops are proliferating in strip malls and in art supplies stores; these generally charge less than other frame shops, making presenting your work relatively inexpensive and easy. Unless you have access to a good woodworking shop and are skilled in the use of carpentry tools, I would not recommend that you try to frame (either under glass or not) a work on paper yourself.

FRAMING WORKS ON CANVAS OR BOARD

Framing works on canvas or hardboard (or another, similarly sturdy ground) is different from framing a work on paper, because such works usually do not require glass protection. Framing these so-called "easel paintings" still provides a level of safety, however. Generally, a frame for a painting on canvas or hardboard is slightly deeper than the painting, so that when you move the work in and out of a rack in a museum or gallery, the facing of the frame—not the surface of the painting—takes any of the abuse. Besides protecting a painting, a frame "introduces" the picture plane. It is the guardian of the work's statement both conceptually and physically.

Even so, many painters do not frame their works, simply leaving the sides of the canvas or board as they are. If you don't want to frame your paintings, you're probably not taking too great a risk, but be warned that repairing a damaged painting is no easy job, especially if it has had a final coat of true varnish. You will have to remove the varnish before any surface repair can begin, because new paint applied to the varnish coat will eventually peel off.

If you have a piece you want to submit for a show, it may be worthwhile to invest in a professionally made frame. I follow one rule when framing any work: the frame should protect and enhance the work but not call attention to itself. Frames, like mats, provide a moment of visual rest in preparation for looking at the painting, and they shouldn't steal the viewer's attention.

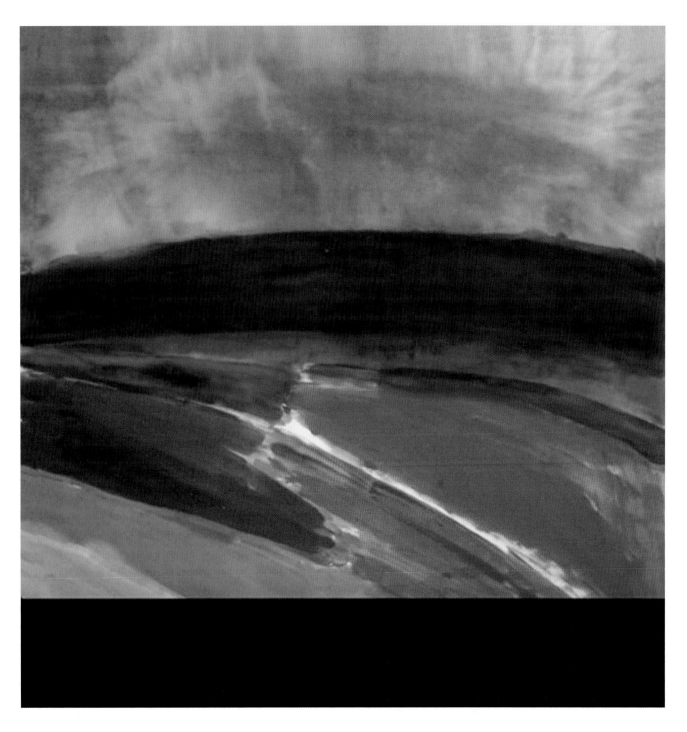

Ronnie Landfield, *Franz Kline in Province Town*, 2010, acrylic on canvas, 88 x 81 inches (223.5 x 206 cm). Courtesy of the artist.

THE NEXT PAINTING

Once you've done one painting, where do you find inspiration for the next? Anywhere. Take the time to thumb back through this book to see which images your eye is drawn to. (They may not be the same things you noticed when going through the book the first time.) Choose one, and see whether you can use just a piece of it to make your own painting. Or pick up your viewfinder and look at something you think you know—but so close-up that you can't see the whole thing through the viewfinder's window. Now, make a thumbnail sketch of what you see. Or sit quietly and imagine shapes fitting together within a rectangle, but with no particular image associated with those shapes. Are any of these images interesting enough to inspire a painting? Better yet, take a painting that you have already done and try running with the idea in as many variations as possible. I did that not long ago with the little life study that appears on page 102, and in one afternoon, I came up with the untitled works incorporating collaged elements pictured opposite. Unless you knew the connection, I doubt you would associate any of these with the original painting. If someone as rigid as I am can throw off the restraints, why not you?

One thing that is very important is to show your work to others. This is not vanity. You want people to look at your work. This is what art is about—communication. Whether your work is realist or abstract, it is your unique vision of color, shape, light, and texture. And others should celebrate it with you.

If you're just at the point where you're ready to show your work, there are lots of opportunities open to you: art fairs, competitions, juried shows, invitational exhibits, and other venues. Finding a commercial gallery to represent you is a trickier matter, but it's a worthwhile goal, if you've begun to develop a solid body of work. If it were not for commercial galleries—which serve as agents, publicists, and marketers

Opposite, Clockwise from Top Left:
James Van Patten, *Variations on the Theme: Figure with Gray Wall, Number 2,* 2009, acrylic with collage on canvas, 12 x 12 inches (30.48 x 30.48 cm); *Variations on the Theme: Figure with Gray Wall, Number 3,* 2009, acrylic with collage and cord on canvas, 12 x 12 inches (30.48 x 30.48 cm); *Variations on the Theme: Figure with Gray Wall, Number 4,* acrylic with collage on canvas, 12 x 12 inches (30.48 x 30.48 cm); *Variations on the Theme: Figure with Gray Wall, Number 5,* acrylic with collage on canvas, 12 x 12 inches (30.48 x 30.48 cm); *Variations on the Theme: Figure with Gray Wall, Number 1,* acrylic and colored pencil, 12 x 12 inches (30.48 x 30.48 cm).

as well as exhibitors—we full-time artists would not be able to do what we love in the way we want to do it. Galleries make art what it is today. I am particularly grateful to OK Harris, in New York City, for representing me for thirty years.

Who knows? The next painting you do may someday be shown in a gallery somewhere. Someday, some critic may write about your sense of color or your innovative technique. If originality is what is valued in the art world (and it is), what do you have to lose? My advice is to take chances—after paying attention to everything you possibly can.

Rod Penner, *Catalina Motel, Wichita Falls,
TX* (detail), 2006, acrylic on canvas,
45 x 63 inches (115 x 160 cm). Courtesy
of the artist.

ABOUT THE AUTHOR

James Van Patten is a native of Seattle, Washington, where he graduated from the University of Washington in 1965 with a BA in art education with an emphasis on painting. He completed his MFA in 1968 in Painting with minors in both Art History and Printmaking from Michigan State University. He has taught painting (as well as other studio classes), and lectured in art history at the university level in the ensuing years on both coasts and in the Midwest. Presently, he is a professor of painting at the School of Visual Arts in New York, NY. There he has taught the only course in acrylic techniques offered by SVA for over twenty years. He's spent bulk of his career in the studio as a practicing artist, working primarily in acrylic paint on large-scale landscape paintings. OK Harris, New York, NY represented him exclusively for over thirty years, and for over a decade the Plus One Gallery of London has shown his work exclusively in England. His work is featured in collections throughout the United States and Europe.

INDEX

Copyright © 2016 by James Van Patten

Published in the United States by Watson-Guptill Publications, an imprint of the Crown Publishing Group,
a division of Random House LLC, a Penguin Random House Company, New York.
www.crownpublishing.com
www.watsonguptill.com

WATSON-GUPTILL and the WG and Horse designs are registered trademarks of Penguin Random House LLC.

All art is by the author, unless otherwise noted in the text.

Library of Congress Cataloging-in-Publication Data
Van Patten, James, 1939-
The acrylic painter : tools and techniques for the most versatile medium / James Van Patten.—First Edition
pages cm
Includes bibliographical references and index.
1. Acrylic painting—Technique. I. Title.
ND1535.V36 2016
751.42'6—dc23
2015012215

Trade Paperback ISBN: 978-0-3853-4611-5
eBook ISBN: 978-0-3853-4612-2

Printed in China

Design by Emily Blevins

10 9 8 7 6 5 4 3 2 1

First Edition

Front Cover: James Van Patten, *Looking on the Other Side*, 1981, acrylic on canvas, 48 x 64 inches (122 x 162.5 cm). Private collection, New York.

pp. ii–iii: James Van Patten, *Shadow and Reflection*, 1993, acrylic on linen, 48 x 72 inches (122 x 183 cm). Private collection.

p. iv: James Van Patten, *Light Late*, 2010, watercolor and acrylics on watercolor board, 10 x 13 inches (25.4 x 33.02 cm). Courtesy of Mr. and Mrs. Daniel Williams, New Jersey.

Back Cover, Clockwise from Top Left:: Elektra Rose, *Three Pears*, 2010, acrylic on canvas, 20 x 10 inches (50.8 x 25.4 cm). Courtesy of artist; Marcia Burtt, *Ebb Tide, Otter Point*, 2011, acrylic on canvas, 18 x 30 inches (45.5 x 76 cm). Courtesy of artist; Mel Prest, *Melphoto*, 2013, acrylic on panel, 12 x 12 inches (30.5 x 30.5 cm). Courtesy of artist.